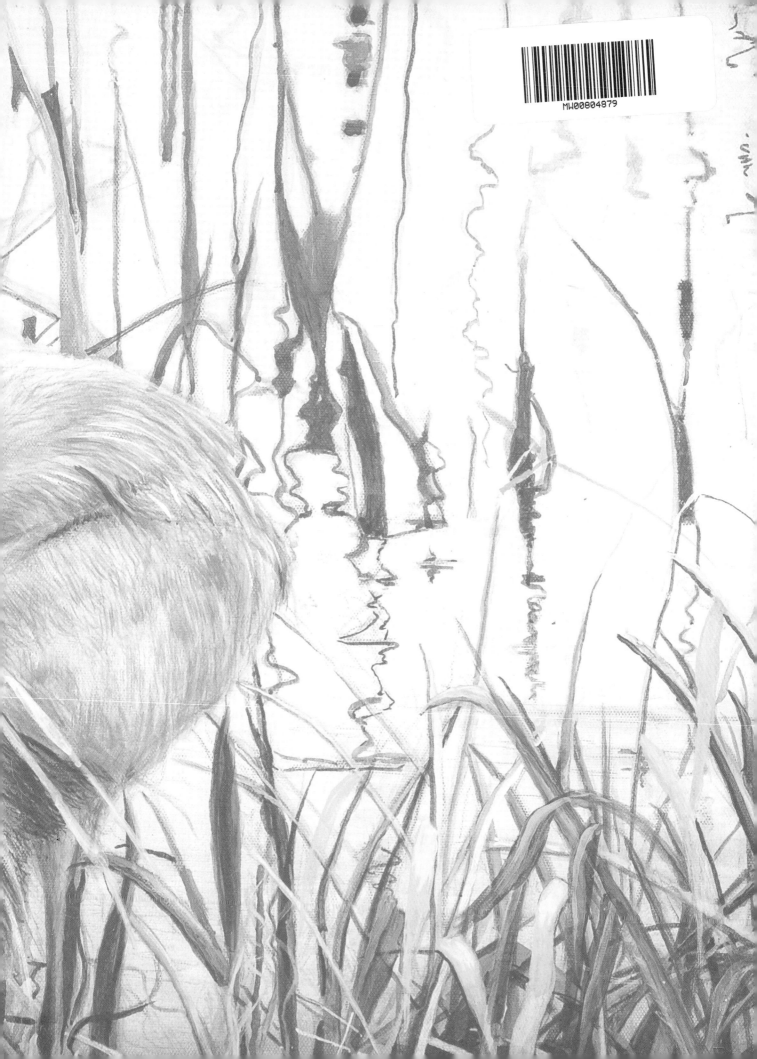

THE ART OF
Angela Gaughan

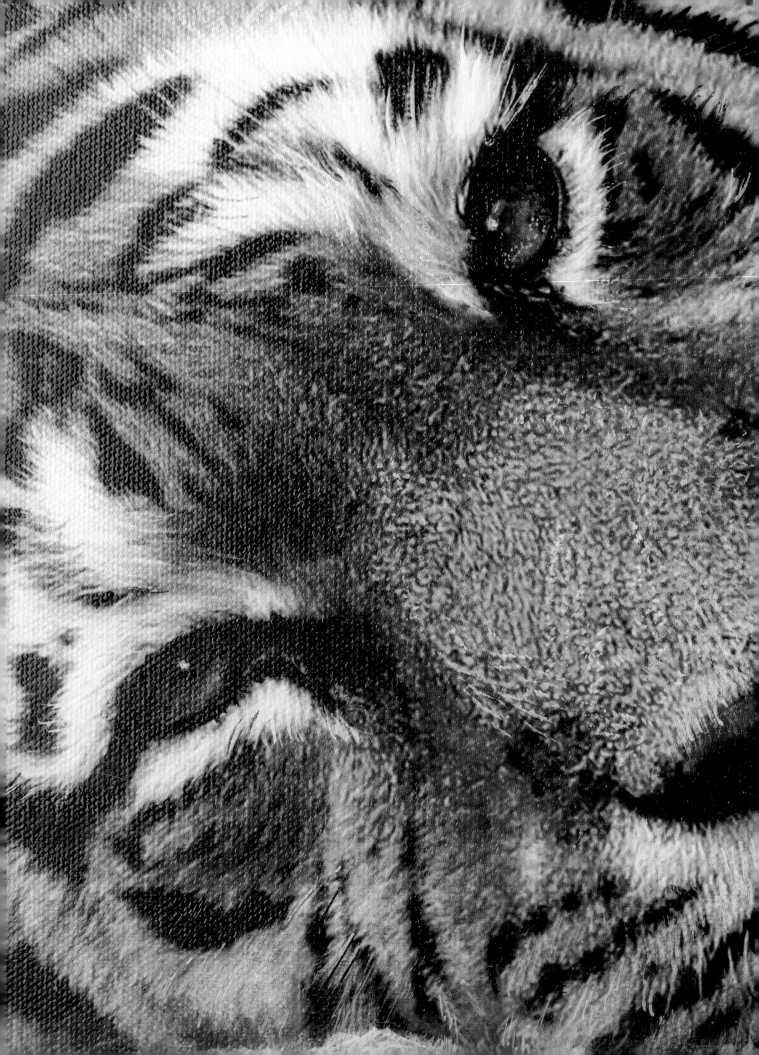

THE ART OF
Angela Gaughan

Techniques &
inspiration for
painting wildlife
in acrylics

SEARCH PRESS

Dedication

I would like to dedicate this book to Mike, who has been the wind beneath my wings. Without his patience and support this book would not have been finished. Also to my sons, Gino and Marco, with love and to encourage them to follow their dreams.

Acknowledgements

I would like to thank Tony Frazer Price; Pauline and Ian Saggers; and Mike, my husband, for the wonderful photographic references.

Edd Ralph, my editor, for all the hard work, patience and encouragement.

Also, my thanks to the design team at Search Press for their creative input.

First published 2021

Search Press Limited,
Wellwood, North Farm Road,
Tunbridge Wells, Kent TN2 3DR

Text copyright © Angela Gaughan, 2021

Photographs by Mark Davison at Search Press Studios, and Michael Owens on location. Additional photographs as credited in captions, except for page 88 (top), Julian Berengar Sölter.
Photographs and design copyright © Search Press Ltd. 2021

ISBN 978-1-78221-798-5
ebook ISBN 978-1-78126-755-4

The Publishers and author can accept no responsibility for any consequences arising from the information, advice or instructions given in this publication.

Readers are permitted to reproduce any of the paintings in this book for their personal use, or for the purpose of selling for charity, free of charge and without the prior permission of the Publishers. Any use of the artwork for commercial purposes is not permitted without the prior permission of the Publishers.

Suppliers
If you have any difficulty obtaining any of the materials and equipment mentioned in this book, visit the Search Press website for details of suppliers: www.searchpress.com

You are invited to visit the author's website at: www.angelagaughan.co.uk

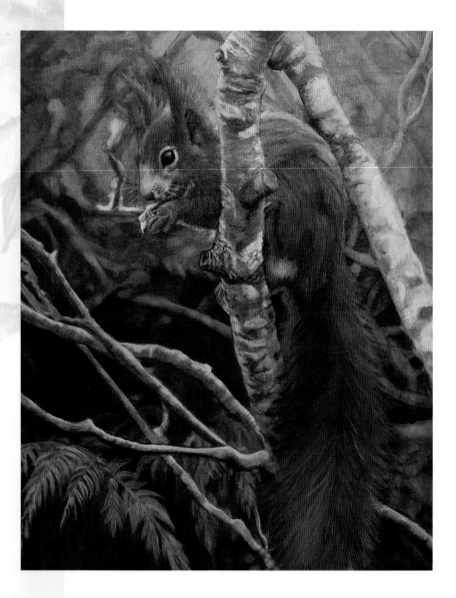

Cover:

Bonding
84 x 64cm (33 x 25in)

These wolves were photographed at a wolf sanctuary in East Anglia many years ago, though the painting was made relatively recently. I loved the way that these young wolves were interacting with each other.

Page 1:

The Crossing
81 × 61cm (32 × 24in)

This painting shows movement and dynamism – the techniques used are explained on pages 132–133.

Pages 2–3:

Vladimir
119 × 36cm (47 × 14in)

A close-up detail of the painting on pages 140–141.

Contents

Foreword BY TONY FRAZER PRICE

While I was weaving my way between stalls and artists at their easels at Patchings, the Art and Craft Festival, I saw a tiger emerging from a canvas as an artist with a very small brush added another whisker on the head of this majestic beast. The lady wielding the brush was Angela Gaughan, a well-known and much admired wildlife artist with, as I learned, many tributes to her skill, including the prestigious David Shepherd and Simon Combes awards.

As we talked, I learned that Angela's preference is to conjure up the magic of amazing beasts, at ease in their natural surroundings. Not for Angela the sweeping stroke of an oil brush, but instead the slow and delicate moulding of her animals with her finely-pointed brush. Our conversation ranged, but it was evident that Angela suffered from a dearth of good reference material. My own travels over much of the globe have given me the privilege of seeing many wonderful animals, particularly the big cats in their natural surroundings, giving me the opportunity of capturing something of their beauty through the eye of my camera. I offered Angela the use of my photographs, and this book features some of the resulting images, ranging from the statuesque

wolf amid the electrifying moss green of the Bavarian forest, to the leopardess and her impish cub in Botswana that you see on the facing page.

There is much issue concerning the use of photographs being used for paintings. Horses for courses – but part of me wonders how Angela could otherwise get the elephant or giraffe to stand still for her, hour after hour, as she sits labouring over her masterpieces. Even outside of wildlife painting it is often only the camera that can catch that fleeting moment that the painting needs to capture in order to make it sing.

My own interest in photographic reality comes from my time as Publisher of the now sadly departed *Illustrated London News*. First published in 1842, prior to the existence of practical commercial photography, the editors of this illustrated news magazine relied on the artists of the day to paint, in photographic style, the stories of the moment. It is said that both Van Gogh and Degas were turned away as their art was too impressionistic for the realism demanded, but such is her skill and accuracy, I have no doubt that this would have been Angela Gaughan's heyday!

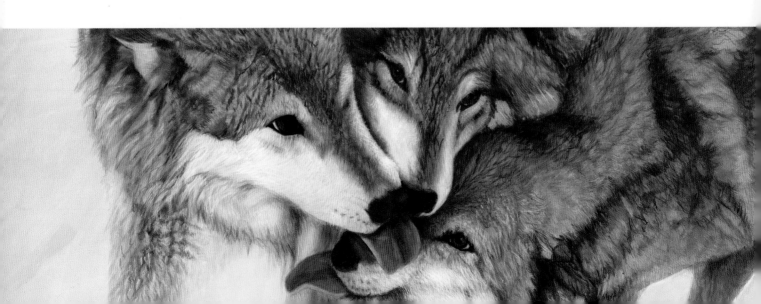

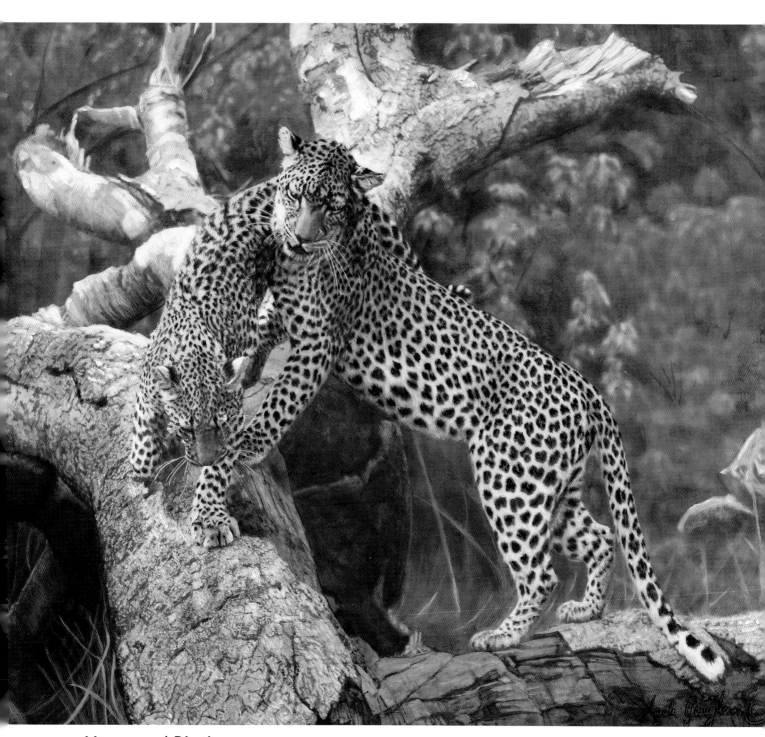

Mama and Binti

91 x 71cm (36 x 30in)

I fell in love with this photograph, one of three that Tony Frazer Price gave to me, each showing interactions between this mother leopard and her cub. I just could not wait to paint it. Here, I wanted to focus on the close bond between mother and cub, so most of the detail is in the leopards and the foreground tree, while the background is more diffused, to push it back.

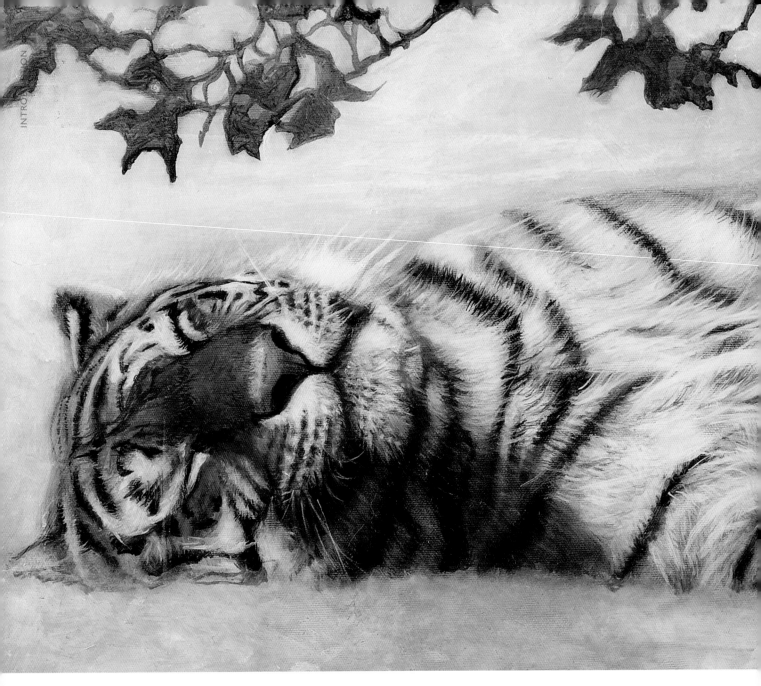

Introduction

As far back as I can remember, I always wanted to be an artist. When I came to write this book, it prompted the simple question: 'why?' Looking back over my life and all the different artists I have met and known, I think the first painting that had a big impression on me was a portrait of my mother, by the artist Henry Bird (1909–2000). As far back as I can remember, this painting hung above the fireplace. I would spend many hours studying it, wondering how he had achieved such beautiful skin tones. The portrait was later joined by pencil drawings of my sister and myself, but it was that portrait which had a big impression on me.

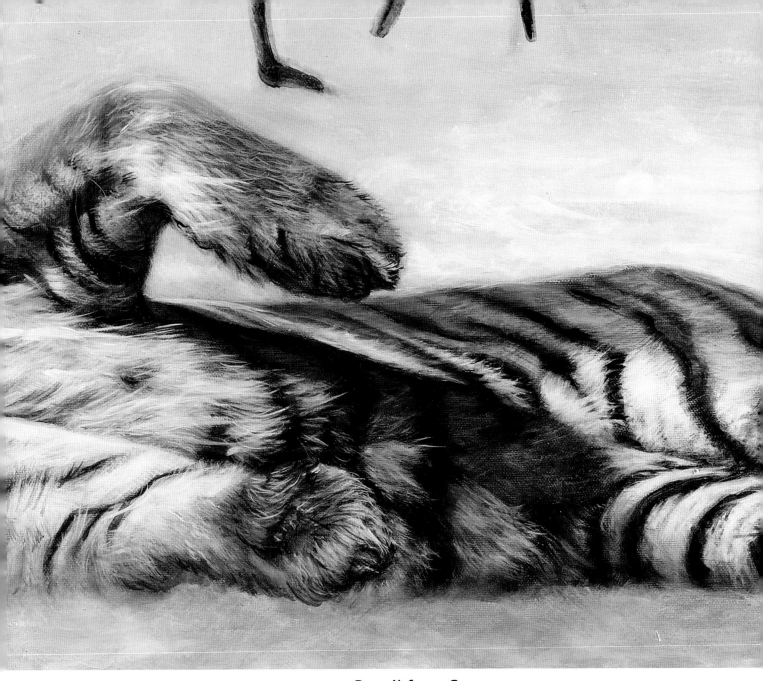

Detail from **Contentment** 91 x 38cm (36 x 15in)
The full painting can be found on pages 118–119.

At the age of sixteen I was asked to model for artist Andrew Vicari (1932–2016) as he was painting a series of three oil paintings collectively entitled *The Three Graces*. This was a wonderful opportunity for me to watch him paint, mix colours and help him in his studio. Vicari took nine-and-a-half months to complete just my painting; and when all three paintings were complete they were accepted and hung in the Louvre in Paris.

Vicari was impressed with my drawing and encouraged me to paint my first oil painting – a self-portrait – by looking in a mirror. By then I was hooked and knew I wanted to be an artist.

I went on to paint many commissioned portraits and pet portraits. As the years passed, I found myself exploring more subjects and media beyond oil paints: demonstrating for various companies including Daler-Rowney, Derwent pencils, Max Grumbacher oils, and Winsor & Newton, for both watercolour and acrylics.

Today, I am an artist of varied interests and the end results are reflected within my work. I paint a broad range of subject matter; I find it is easy to draw inspiration from many different sources.

I feel the best paintings tell a story and as such evoke an emotional response. Whether as artist or audience, I believe painting can help most people if they make time for it. My artwork is thus always inspired by the two underlying concepts of Classical art: beauty and craftmanship. The value and importance

of these have become depreciated in some circles over the last few decades, and so one of my aims – through both my painting and in this book – is to recover and bring them back to prominence in contemporary art. I think beauty and craftsmanship are not merely important: they are necessary for health and happiness.

With today's busy lifestyles, it is more important than ever to make time for ourselves. Painting is perfect for this. Concentrating on your painting is meditative: as you focus on what you are bringing to life, everyday worries seem to fall away. There is something about working with colours that is very therapeutic and healing, and when your painting is finished, you have a great feeling of satisfaction. I hope this book helps you find the pleasure of a good job well done.

'Turn off your brain and draw what you see.'

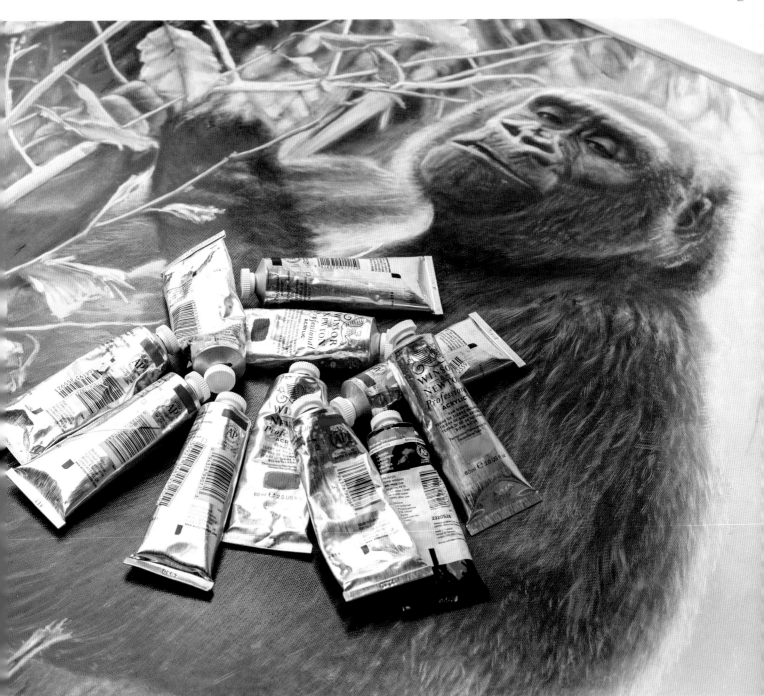

what I use to paint

Over the years I have used many different types of paints, surfaces and tools – visiting art shops and seeing all those lovely paints and brushes makes it very tempting to buy one; you feel just like a child in a sweet shop!

It has taken me a long time playing and experimenting with my materials to achieve the methods I use to paint now. I spent many years demonstrating techniques for Derwent – or the Cumberland pencil company, as it was then – so naturally I am familiar with the range. It was natural to select what I needed to do my master and tonal drawings from Derwent, but there are other high-quality drawing tools with which you may wish to experiment.

Let me be clear that this book is not about telling you how you should paint, or what you should use, but rather about how I have developed my own way of painting to achieve the quality and detail I wanted to achieve.

I have refined and adapted my techniques so that my approach is the same, regardless of whether I am working in acrylics or oils. The only change is the medium I use to mix the paints. The majority of the paintings in this book are in acrylics, but you could equally well apply the lessons learned to oils, should you so wish.

The advantage of acrylics is that they dry a lot faster, but by mixing with a slow-drying medium you can slow the drying time to suit yourself, and bring them closer in feel to oils. Oils are slower to use. Just one glaze will take at least twenty-four hours to dry. You can use alkyd medium to speed up the drying time but they are still a lot slower than acrylics.

What I would like you to take away from this is that while good-quality materials are important, it is more important to find tools, paints and surfaces that you enjoy using. Experiment, play, and enjoy.

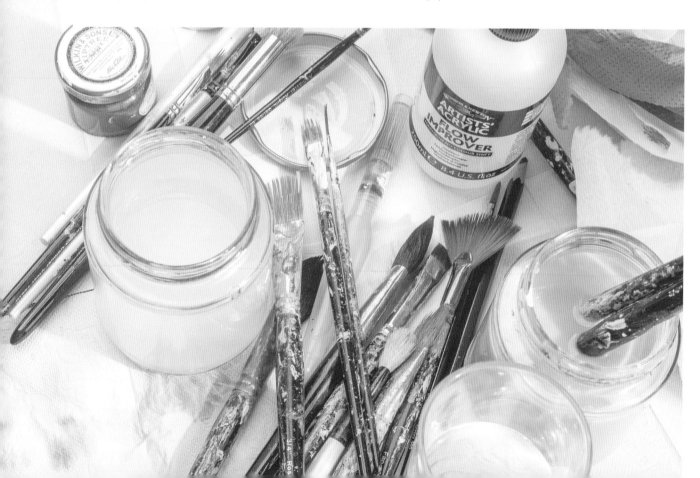

Brushes

The brushes here are my everyday go-to brushes, and were used on all the acrylic paintings in this book. However, I find brushes are a personal choice. A lot depends on how you hold your brush, for example – the weight and balance, and whether you prefer a long or short handle. What is right for me might not be right for you, so experiment to find the right brush for you. When you have the brushes you are happy with, look after them and wash them out in warm soapy water after every painting session, especially with acrylics.

I will say buy the best you can afford. Make painting enjoyable; don't struggle with brushes that do not do the job you want them to. I source my brushes from Rosemary & Co, as I have always found this company very helpful when I need advice on which brushes to use for special purposes.

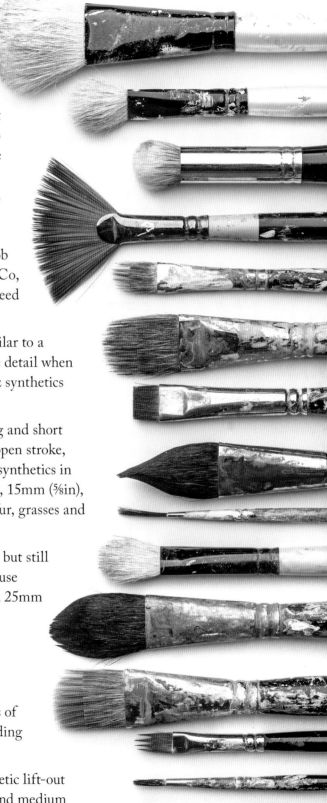

Riggers Also referred to as script brushes, riggers are similar to a round brush in shape, but with much longer hairs. For fine detail when finishing and refining, I use size 2/0 and 0 from the Shiraz synthetics range, as these carry a lot of paint.

Spiky combers Flat in shape, but set with alternating long and short groups of hairs, the quirky shape allows for a much more open stroke, ideal for oil or acrylic artists. I favour Series 2230 Golden synthetics in the following sizes: 6mm (¼in), 10mm (⅜in), 12mm (½in), 15mm (⅝in), 20mm (¾in), and 25mm (1in). I use these for most of my fur, grasses and sometimes trees.

Pointed oval wash brushes Made to hold plenty of water, but still come to a point, these are useful for washes and glazing. I use Series 41, which are pure squirrel hair, in 20mm (¾in) and 25mm (1in) sizes.

Mops Soft goat-hair mop brushes are ideal for softening, blending and feathering, I use the Mundy range in sizes 6mm (¼in), 12mm (½in), and 25mm (1in).

Large soft brushes Made from a blend of different grades of badger hair, the Smooshing brush range are good for blending oils and acrylics. The sizes I use are medium and large.

Eradicators Great for refining whiskers, the Shiraz synthetic lift-out brush is firm enough to remove wetted paint. I use small and medium sizes for control.

Paints

All paints are pigments combined with a binder. Watercolour pigments, for example, are suspended in gum arabic (or glycol, a synthetic equivalent), while oils – unsurprisingly – use oil. The different binders are what give different paint media their various qualities. I have gradually come to use acrylic paints almost exclusively, and most of the artwork in this book is made with acrylics.

Acrylic paints

If you want your paintings to be the best you can paint, I recommend you use artists' quality paints as you get more pure pigment and less binder than with the students' quality. Students' ranges are cheaper, but it is a false economy, as the colours are not as vibrant, nor as long-lasting. Artists' quality paints flow beautifully, even when heavily diluted. I favour Winsor & Newton's Professional Acrylic range because this range has great transparency – an important quality for my work. There are other ranges with similar qualities, so experiment to find the paints you like.

You need only a small number of tubes for the approach that I use, as it means that the paint goes a long way. We will look at my choice of colours in more detail on pages 48–49.

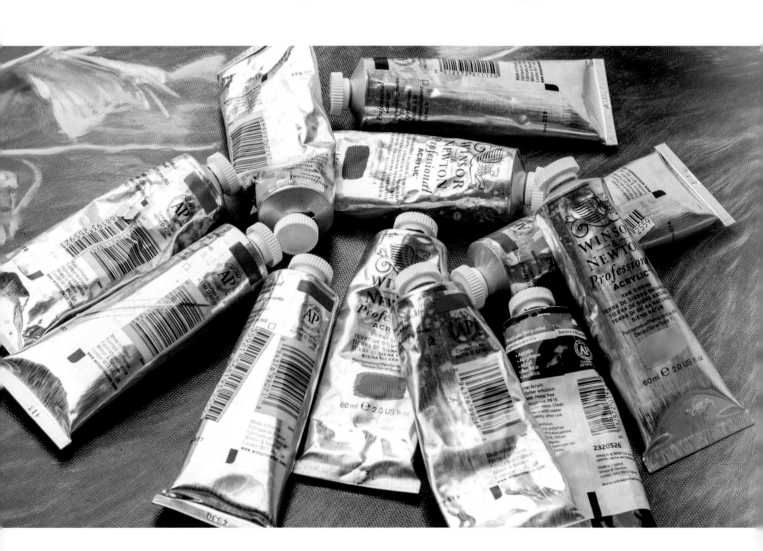

Paint qualities

When I first started using acrylic paints, I was unimpressed. The binders then were a form of acrylic plastic that felt 'gluey' when used; and I stuck with the oils with which I had trained, because they had particular qualities, such as smooth flow and – when diluted with thinner – great transparency.

Over the years, the technology improved and modern acrylics feel smoother to use, allowing for a combination of traditional oil and watercolour techniques to be used. This is owing to their particular characteristics or qualities.

The binders that paints have give them particular qualities, but they can be altered through use of mediums – including plain old water.

TRANSPARENCY/OPACITY

Perhaps the most important quality to me is a paint's transparency. When thinned down with water or medium, transparent colours allow some of the underlying surface to show through. This is particularly useful for techniques such as glazing.

Opaque colours obscure more of what is underneath when laid over the top – though this is also useful for knocking back areas that are too strong. Paints are usually marked as either transparent, semi-transparent or opaque on the tube.

GRANULATION

Some paints granulate, which means that they produce a mottled effect as the pigment sinks into the surface. This is more obvious when using watercolour, but can be used in acrylics.

DRYING TIME

Acrylics typically dry quite quickly – a big advantage over oils for me – but you can slow this down through use of retarder medium.

Other paints

My approach today is based almost entirely on acrylics, but I occasionally use other media, either on their own or alongside my acrylics to develop my artwork in a particular way.

Oils I trained in traditional oil paints, but have gradually moved to quicker-drying acrylics. When I do return to oils, however, I favour the Puro range from Maimeri because I love the buttery consistency and the colour range. I also use Winsor & Newton alkyds. The alkyd carrier in these paints is faster-drying than true oils, giving me the best of both worlds. In both cases, I use liquin as a medium.

When using oils in combination with acrylics, I start with acrylics. The speed of their drying time enables me to work quite quickly, bringing a painting near to completion. I then cover the canvas with alkyd medium – which seals in the acrylics and protects them from the oils – before continuing using oils. The slower drying time of oils makes completing the details and blending of colours much more relaxed and enjoyable.

Watercolour Winsor & Newton artists' quality tube colours are my go-to watercolours. This started for the very simple reason that I was demonstrating them while teaching on cruises; but even today I love the range of colours! Whatever range you choose, I recommend tubes over pans, as tube colours require less work to get ready to use.

Mediums

Usually colourless, mediums are materials that can be added to paints that alter their characteristics, such as making the paint dry faster or slower, adding gritty texture, making the paint thick for impasto technique or improving its flow. There is a huge range of mediums available for paints, and particularly for acrylics, so I will detail just those I typically use here.

For readers who have used oils, the concept of mediums will be second nature: the turps, liquin and so forth used to thin your paint and clean your brushes are mediums.

My style relies on using acrylics paints pre-prepared with mediums I mix myself from the following ready-made products:

Flow improver As the name suggests, this lowers the surface tension of any paint with which it is mixed. The result is a smoother, silkier feel to each brushstroke. Think of it as a way of watering down your paint without the risk of it becoming too thin and breaking up.

Slow-drying medium Acrylics naturally dry much more quickly than oils. While this can be handy, adding slow-drying or retarding medium allows you to control the speed at which it dries, extending the working time.

Glazing medium A colourless medium that produces smooth, quick-drying layers, glazing medium can be mixed with tube colour or again it could be painted over the whole canvas to seal in the paint. I apply a layer of glazing medium all over the canvas on a finished painting to seal in the colour before varnishing. This ensures that if there is any reason to remove the varnish in the future, you will only remove the varnish and not the paint – it is safely sealed behind the glazing medium.

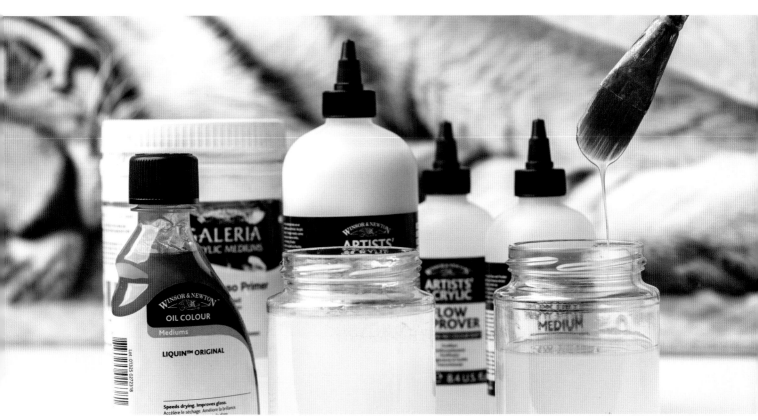

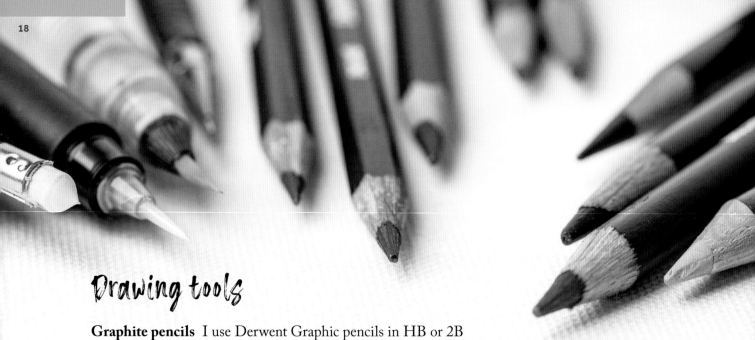

Drawing tools

Graphite pencils I use Derwent Graphic pencils in HB or 2B grade for sketching and drawing out images. As I do quite detailed drawings in graphite, I also use a clutch pencil as it gives me a clean, consistent line and saves me sharpening time. Many manufacturers produce good graphite pencils – just make sure you have graphite leads and that the lines can be erased. The reason I am making this clear is that high-polymer leads can produce marks that are difficult or impossible to remove from canvas.

I experimented with high-polymer leads for the *Zebras* project on pages 38–45 and found it impossible to erase. It was very messy – my hands were black! – and produced smudges which were impossible to erase. The only way I could clean it up was to paint it out with white gesso. I will not be using them again, so if you want a clean, detailed drawing, use graphite.

Inktense pencils Derwent's Inktense pencils are watersoluble coloured pencils that produce permanent marks, like ink. This means that, once dry, Inktense will not lift and washes of paint can be safely worked over them.

When applying the Inktense, I do not draw with it. Instead, I put Inktense onto a piece of watercolour paper which I then use as a palette; picking up the Inktense with a wet brush and painting with it (see page 37).

I use brown (Bark) to put in the darkest tones in my drawing first, then I mix it with a pool of water on watercolour paper to grey it down to paint the midtones. I occasionally use a black pencil (Ink black) depending on the subject.

Electric eraser This is good for erasing small areas and also for lifting highlights.

Water brushes Consisting of a reservoir of water and a brush tip, these are used to create the tonal underpainting (see page 36). Fill the water brush with tap water and you can carry it with you for making watercolour or Inktense colour notes when you are on site.

Fine liner Used when transferring the master drawing to canvas; I favour a Unipin fineline 0.3mm pen.

Surfaces and grounds

I work on various surfaces, primarily canvas – as my artwork is very detailed, my preference is to work on a very fine canvas, with little obvious texture.

Because such fine canvases are hard to find, I purchase my canvas on a roll and my husband makes my canvases to the size I require; a local framer could provide a similar service. I then gesso the canvas three or four times, using sandpaper in between coats, in order to give a smooth, even surface on which to work. This is described on page 32.

I also use Daler-Rowney watercolour board because they are robust enough to take the abuse of the numerous washes my approach demands.

Camera

I would advise any artist to purchase the best photographic equipment that they can comfortably afford, as reference is essential to producing quality paintings.

My photography kit for wildlife consists of a Canon EOS 5D Mark IV full frame camera with a 100–400mm zoom lens which allows me to get clear photographs without the risk of alerting or disturbing my subject. I use the lens with an 2x Extender, which increases the distance at which I can shoot without the cost of a more expensive zoom lens. For less elusive animals, such as squirrels and domestic pets, I use a 70–100mm or 28–135mm lens.

My photography equipment is expensive but it gives me the quality and detail I need to produce my paintings.

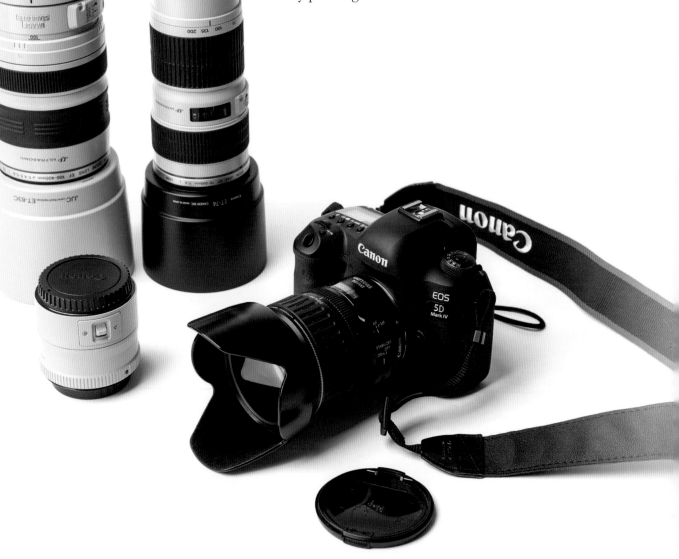

Other materials

Tracing paper I draw with a graphite pencil on tracing paper for all my master drawings. This allows me to plan the painting and rectify any problems before transfering it onto canvas. I favour a Daler Rowney A3 size (29.7 x 42cm/11¾ x 16½in) tracing pad.

Tracedown paper This is used for transferring the master drawing from the tracing paper to the canvas.

Easel (not pictured) A sturdy studio easel will let you work comfortably.

Mahl stick A stick that lets you rest your wrist without leaning on the wet canvas surface, allowing for extra detail in your painting. I have two, a traditional round-headed one and one with a shaped head that I designed and my husband made. The shaped end allows it to hook onto the top of the canvas so I always know where it is. It can also be used as a set square for drawing vertical and horizontal lines.

Electric pencil sharpener For drawing detail you need a very good point to your pencil. Avoid wasting your time sharpening by hand with a scalpel, and instead use an electric sharpener.

Hairdryer This is used to dry washes and glazes when in a hurry and for drying wet blending brushes.

Kitchen paper This is used for removing excess water from brushes, drying them, and general cleaning duties.

Glass jars My method of painting requires lots of small amounts of thinned paint. I have found that small jam jars are ideal for storage and use.

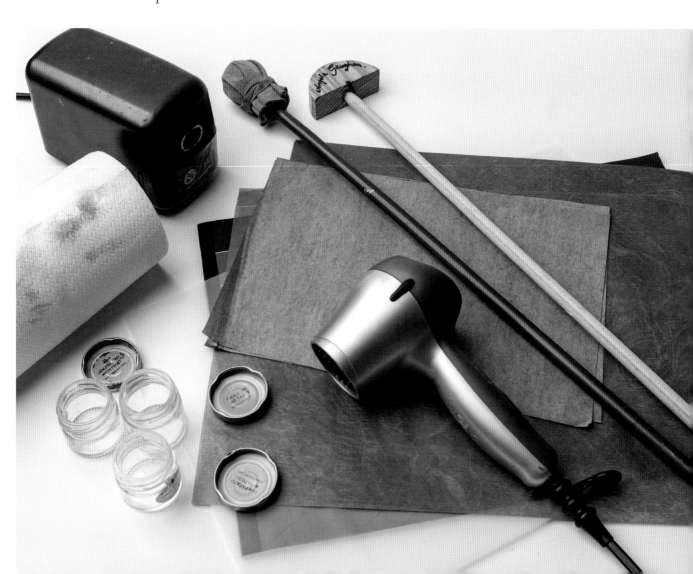

My approach

When I started drawing as a child, my main interests were people, flowers and pets. At the age of sixteen, with the help and tuition of artist Andrew Vicari, I started painting commissioned portraits in oils in the *alla prima* style, but after studying many different subjects and styles I found myself wanting to paint more and more detail. Alla prima is a direct style of painting, which means that the colours are mixed on the palette, then applied to the surface.

For the past few years I have used an indirect method: building up many layers of pure, unmixed colours in combination on fine canvas. Because the paint I use is thinned-down, each layer modifies rather than obscures the previous one. In this way, depth of tone and subtlety of colour are built up.

It is a time-consuming process, but I really enjoy the unique qualities it can give. The surface becomes eggshell-smooth and offers delicate tonal variations that are impossible to achieve with any other method. I use acrylic paints primarily because they dry faster than oils, enabling me to build my layers of paint quite quickly.

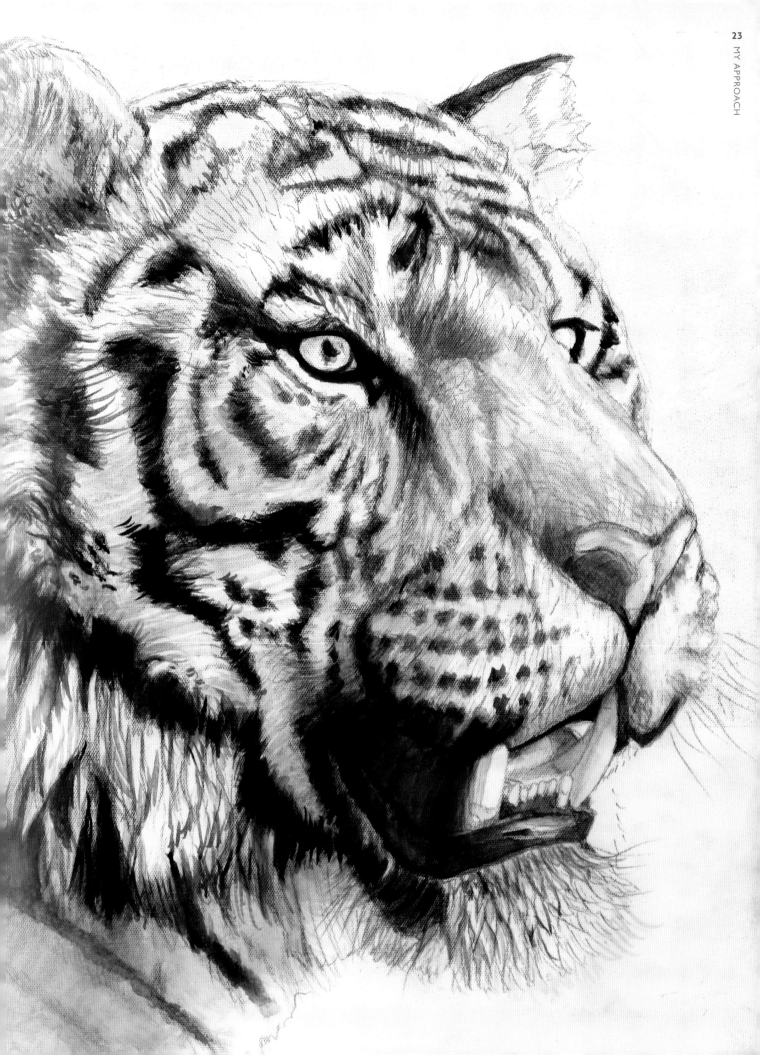

Daylight: setting up your studio

Finding a well-lit place to work is essential. Good, consistent light is very important to all artwork. Quite apart from avoiding the eye strain that will come from working in dim conditions, working in good lighting helps to make sure that the colours you paint are accurate.

Artificial lights are often yellow-tinged, which makes matching colours harder, so if at all possible, try to find a space to paint that has plenty of natural daylight. Ideally, find a room with a north-facing window, as this will give clear light throughout the day while avoiding periods of direct sunlight.

When setting up in my old studio I was very lucky to have both space and northern light. My easel was placed next to my patio doors, and I had a drawing board placed close to the window which gave me good working light throughout the day.

When we decided it was time to downsize our home, however, we ended up in a lovely little period cottage, where I found myself making space to paint in my kitchen. I now use a daylight lamp (a special blue-tinged lightbulb that effectively simulates daylight) attached to my easel which gives me a good light with which to work.

This shows you that while a dedicated studio with north light is desirable, it's not essential. Everyone's home will contain a small corner where you can paint if you really want to.

My studio set-up, with as much daylight as possible, and all my essential materials – including a hot drink! – close to hand.

Working at life size

When working I like to blow up the photograph to the size I want to work it – usually near to life size. I do this by putting the image onto a memory stick, then taking it to a printers to get it blown up to size.

The photograph is then taped onto a piece of foamboard – or two, as in large examples like *Vladimir*, shown here – and placed in the best position for me to study and draw it. This ensures all the details are rendered as clearly as possible. It also means that there is no need to scale up the drawing – you can copy angles and measure distances with no conversion necessary.

Of course, the practicalities are just a benefit to the process – the real reason to work at life size is to impress upon the viewer something of the impact that the subject has in real life. Vladimir, for example, is such a beautiful animal that painting him at life size helps to show what a magnificent beast he is.

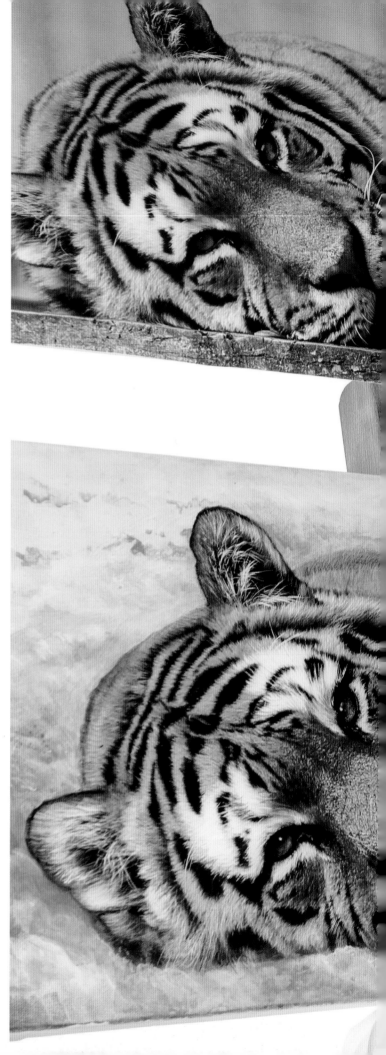

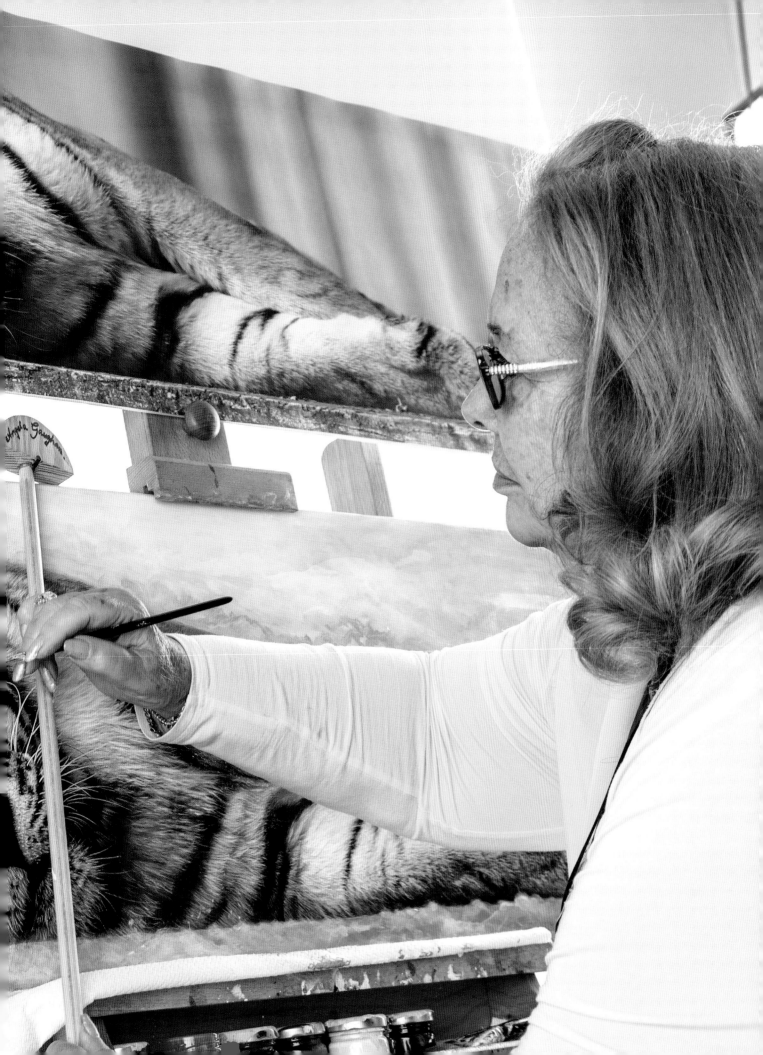

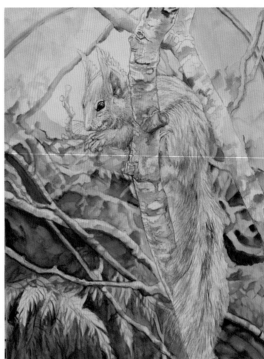
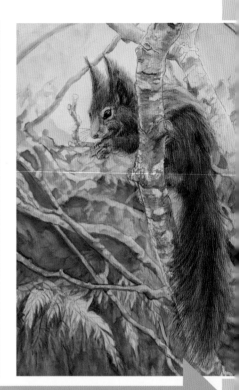

The working process

I start by choosing a photograph and make a very detailed graphite pencil drawing from it. I then work over it with Derwent Inktense pencils, used as paint, into a monochromatic underpainting. Over this, I gradually add colour, using both transparent glazes and full-bodied acrylic paint. You can see the process from start to finish on these pages, and the practical elements of how to do it are explored in this section of the book.

The glazing technique is essential to this approach, as it is the reason that a small selection of clean, pure colours can appear as a multitude of different hues. In this painting of a squirrel, the first wash over the underpainting (above centre) was lemon yellow. Laying yellow over grey results in the green you can see in the midway stage above right. Note the variety of greens that appear from one wash, thanks to the variety of underlying grey tones. Further washes can enrich the colour, or vary it, as we will see later.

Once the yellow had dried, I used a wash of burnt sienna over the squirrel only. The warm red of the colour mixed with the existing yellow, creating a rich orange. Once this was dry, I began applying washes selectively to build up tone; adding burnt sienna into the background, to suggest dead leaves, and thinly on the branches. You can see how the subsequent layers of burnt sienna on the squirrel have built up to create impact and vibrancy, too.

Starting with a carefully composed photograph, blown up to the size I wish to work (above left), I draw out a master copy to experiment with composition. Once I am content, I transfer that to canvas and build up an underpainting (above centre). From here, it's onto rich colour, built up with layer after layer of thin, transparent glazes (above right). After refinement, the painting is complete (see opposite).

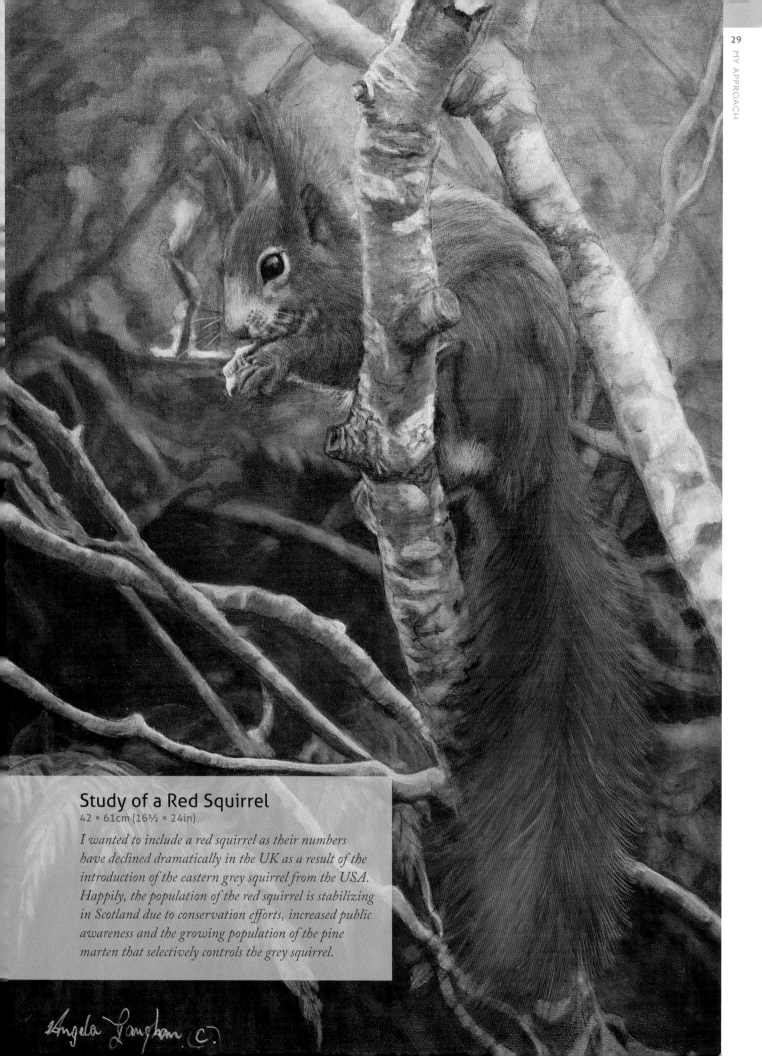

Study of a Red Squirrel
42 × 61cm (16½ × 24in)

I wanted to include a red squirrel as their numbers have declined dramatically in the UK as a result of the introduction of the eastern grey squirrel from the USA. Happily, the population of the red squirrel is stabilizing in Scotland due to conservation efforts, increased public awareness and the growing population of the pine marten that selectively controls the grey squirrel.

Angela Langham (C)

Master drawings

A master drawing, or master copy, is a preliminary drawing made on tracing paper. Working on this surface, rather than directly on the canvas, allows you to alter and adjust the image as much as you like without damaging the surface of the final painting.

It also provides you with a little insurance – once you have a master drawing, you can use and re-use it. This allows you to experiment with different compositions and backgrounds, for example. Take the opportunity to feel your way around what you want to do before committing to your composition.

Making a master drawing is a traditional way of producing an image for a painting: the Old Masters used wax paper in much the same way as the tracing paper is used here.

All of my work starts with a master drawing, made either from life or from a photograph. I keep all my old master copies, as you never know when a particular pose or angle might come in handy for a new composition.

Creating the master drawing

I recommend that you draw freely rather than trace your image, as it will give you vital practice in measurement and assessment. It will bring you closer to your subject. This familiarity will make the later stages much easier and more enjoyable. With that said, if you wish to trace your chosen photograph to get started, then that's also fine.

Tip

Draw from life wherever possible. It is teaching you to use your hands and eyes in concert – once you can do that, the world is your oyster. Working from a photograph is then a simple exercise in measurement and trusting your own experience.

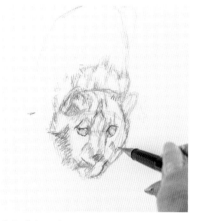

1 Enlarge your chosen photograph to the size you want to work at (see page 26), then use masking tape to secure it in place on your desk. Take a sheet of tracing paper and secure it to the desk next to the photograph. Use a 0.5mm graphite clutch pencil to begin to draw out the image on the tracing paper.

2 Build up the focal area or areas first – in this case the head. These are the most important areas. If something goes really wrong here, you haven't wasted too much time, and can start again.

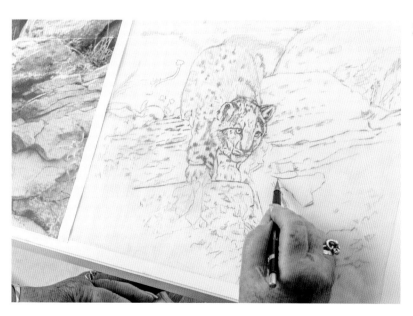

3 With the subject completed, continue building up the image to completion. Try to capture the original as closely and accurately as possible – the closer it is to the original, the more flexibility and opportunities are opened up to you for future composition. This needs to be balanced against the time you spend. Ultimately the master drawing is just a sketch, and the real work starts on the canvas. For this reason, there's not much sense doing much more than hinting at particularly important areas of tone. Concentrate on getting the lines correct.

Preparing canvas with gesso

Canvas is a woven fabric, and thus has a surface texture. For my way of working, I prefer a smooth, near-textureless surface, for the greatest detail possible. Finer-grained canvas can be bought, or you can remove the texture by layering the surface with gesso primer and sanding it flat (better still, I get my husband to do it!).

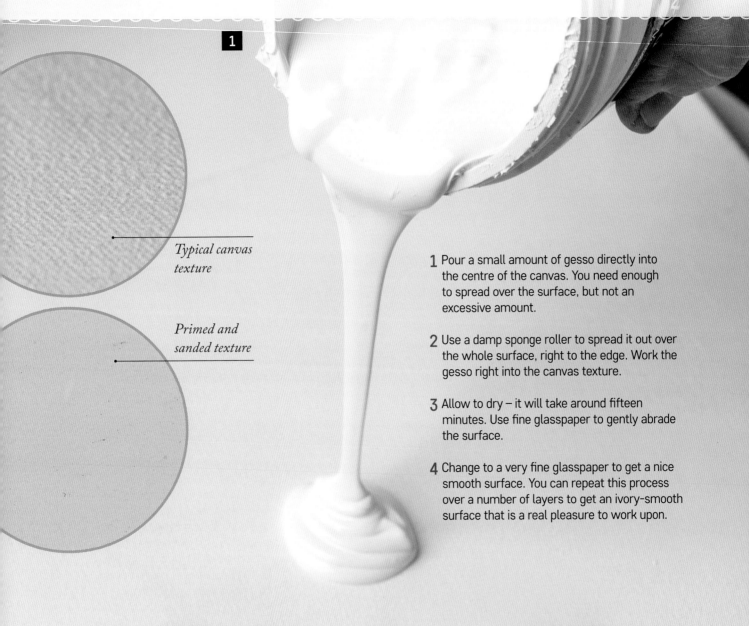

1

Typical canvas texture

Primed and sanded texture

1 Pour a small amount of gesso directly into the centre of the canvas. You need enough to spread over the surface, but not an excessive amount.

2 Use a damp sponge roller to spread it out over the whole surface, right to the edge. Work the gesso right into the canvas texture.

3 Allow to dry – it will take around fifteen minutes. Use fine glasspaper to gently abrade the surface.

4 Change to a very fine glasspaper to get a nice smooth surface. You can repeat this process over a number of layers to get an ivory-smooth surface that is a real pleasure to work upon.

2

3

4

Transferring the master drawing to canvas

Traiditonally, you would prick holes in the lines of the master drawing and rub charcoal over the surface. When removed, it would reveal a 'dot-to-dot'-like image, ready to paint upon. Today we can use use tracedown paper to transfer the image. Before you begin, put a book or other hard surface behind the canvas to give yourself a firm surface to press against to ensure the image transfers cleanly.

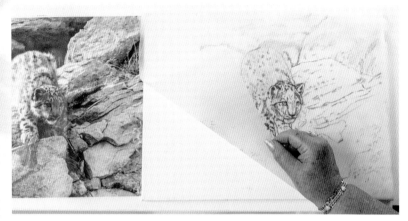

1 Place your prepared canvas (see opposite) on your working surface. Secure the master drawing to the canvas with masking tape at the top.

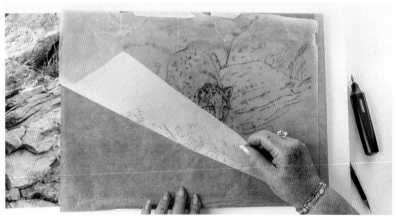

2 Lift the master copy up from the bottom and place a sheet of tracedown paper on the canvas beneath it. Fold the master copy back down over the top of the tracedown paper.

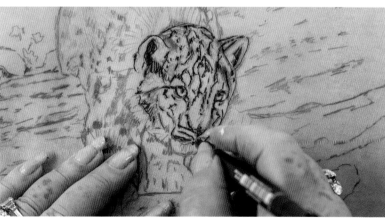

3 Use a fine liner to work over the drawing to transfer the image across. Because it's secured at the top, you can flip it back to check that the image is transferring well every so often.

Composing with master drawings

You can combine two photographs into one painting by making master drawings from different photographs, then moving the images around to make the composition you require.

The picture to the right, of mother and cub, is a perfectly acceptable image, but I want to add another cub to enrich the composition – to do so, I simply introduced the master copy from the previous page.

The process of composing in this way isn't a strict sequence; it's an exploration. Keep moving, changing and trying different options from those here until you find a result you like. There is more guidance on composition on pages 98–111.

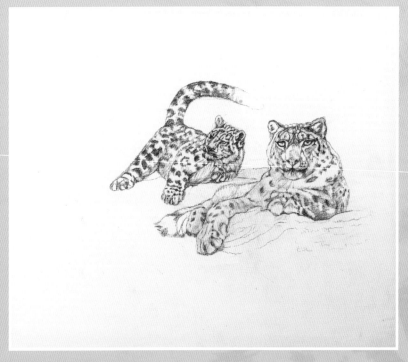

The starting point

Both mother and cub came from a single master copy; there's no reason you can't include more than one animal in a master drawing. In fact, transferring a real interaction from a photograph to a master copy is a good way to ensure the scale and relationship are true-to-life.

Avoid leading out of the picture

I started by placing the master copy for the new cub in a likely area – I chose the top left area, creating a triangular composition with the existing image on the canvas. This works in terms of scale (that is, the cub looks the right size against the others), but he's looking out of the image, off the canvas. This will take the viewer's eye out of the canvas.

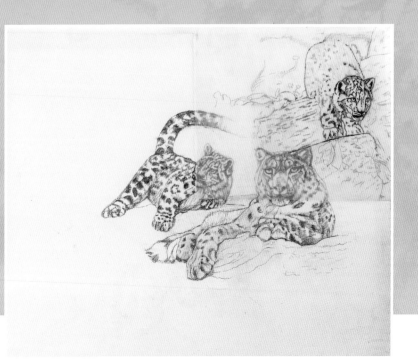

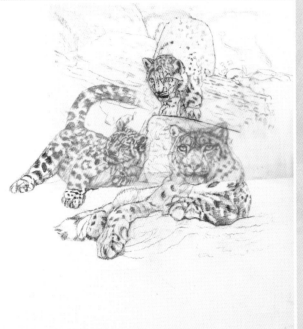

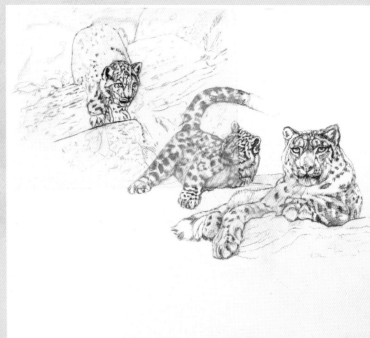

Make use of space

To avoid leading out of the canvas, I tried flipping over the master copy so that the new cub is looking into the image. This composition could work nicely on a smaller canvas, but it leaves too much space elsewhere.

Successful flow

I flipped the master drawing over again and moved the cub to the opposite corner. This also works well, giving a nice flow into the canvas. This is where I decided to place him.

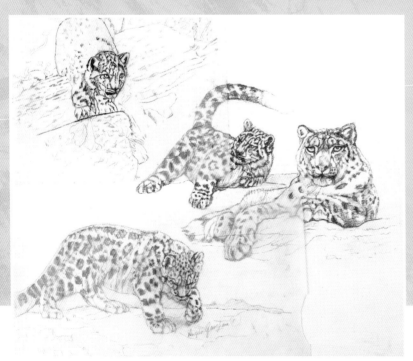

Going further

This left a large blank area at the bottom left, so I used another master copy to introduce a third cub to fill this area.

When working on a large composition like this, with multiple master copies being combined, it's important to keep the scale correct – or at least believable. The best way I have found to do this with animals is to compare the size of their heads.

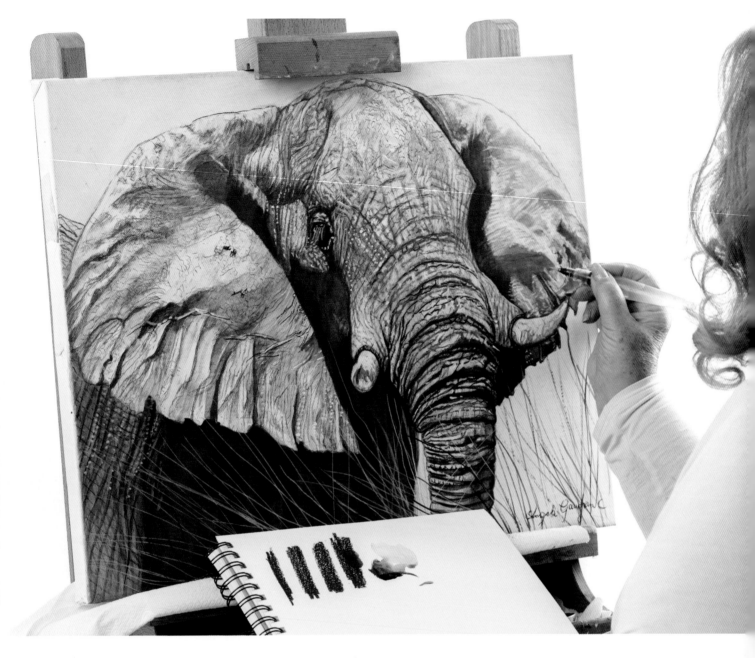

underpainting: the tonal drawing

For my artworks, I start with an underpainting, usually in shades of brown or grey, over which I can paint acrylic glazes. This is an adaptation of an oil technique known as *grisaille*, and results in a clean, rich result.

After completing the drawing and transferring it to canvas, the next stage is to develop it into a complete underpainting in tones of a single colour. I work over the drawing with Inktense pencil, applying it like a paint.

This stage can be time-consuming, but spending time early on, building a full tonal map of the image, leads to a rewarding, relaxing painting process later.

Building tone with Inktense pencils

Once wetted and allowed to dry, Inktense colour is set indelibly, and so you can glaze over the top of it to develop the painting. It also seals in the graphite from the pencil, preventing it from smudging.

At the start of a typical painting, I lay down three or so large dry areas of Inktense pencil on a pad of watercolour paper, which is then used as a palette. Each area is useful until it has been wetted and subsequently dried, at which point you will no longer be able to lift colour from it. Having a few areas pre-prepared allows you to work smoothly, without breaks.

I usually use Bark or Ink black pencil, as these are neutral and versatile enough to give strong darks. Bark Inktense pencil appears almost black when initially applied to the paper, but the difference is obvious when diluted. It gives a warmer finish than pure black.

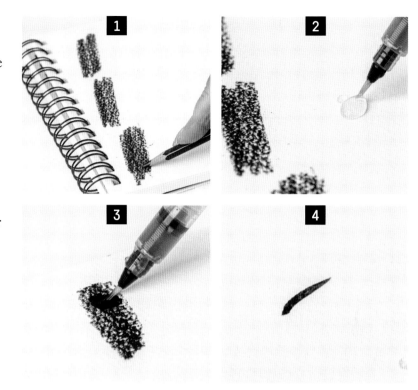

1 Use the side of the pencil to scribble heavily on watercolour paper with the Inktense pencil.

2 Squeeze the water brush to deposit a small puddle nearby. We do this early on while the water brush is clean.

3 Gently wipe the water brush over one of the scribbles to pick up the pencil colour.

4 You can now draw with the water brush, and it will give a strong dark. This is useful for the darkest darks in your composition.

Midtones

For midtones, pick up the pencil colour, then dip the water brush into the pool of water before using it to draw with.

Tints

For lighter tints, simply add more water: the more you dilute the colour, the lighter the result.

Zebra
– Creating an underpainting

As any schoolchild will tell you, zebras are black and white. On one hand, that's true – but as we'll see here, there's a lot of subtlety, too. This project is intended to show you how to build up the subtle variety of tone that is essential to this way of working. When you work glazes of paint over the top of a properly prepared underpainting, all this careful tonal work will pay off.

This way of working is easier, because you're getting all of your problems out of the way early on. You won't have to adjust your colours for value (that is, tone) because all the tonal variation has already been correctly established at this stage.

YOU WILL NEED

Surface: Prepared canvas 86 x 60cm (32 x 26in)
Brushes: medium spiky comber Water brush
Other materials: Permanent black brush pen; Ink black and Willow Inktense pencils; a spare piece of watercolour paper; kitchen paper

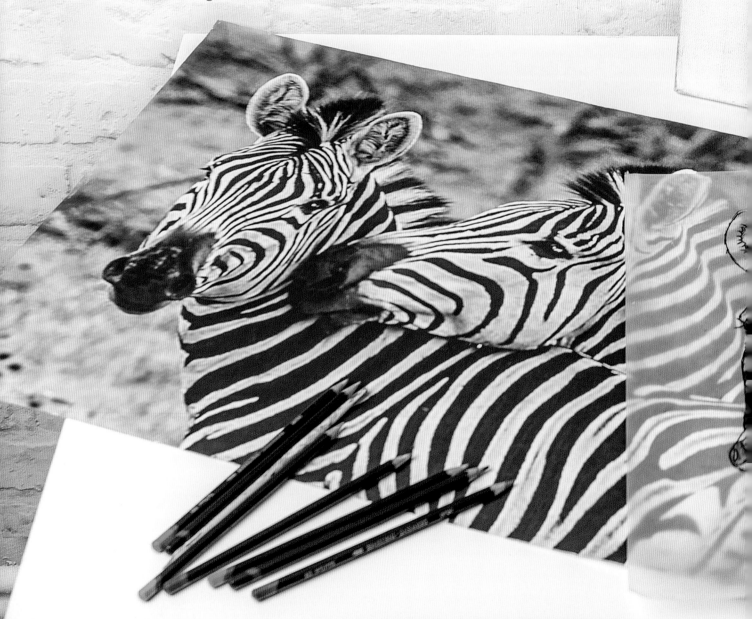

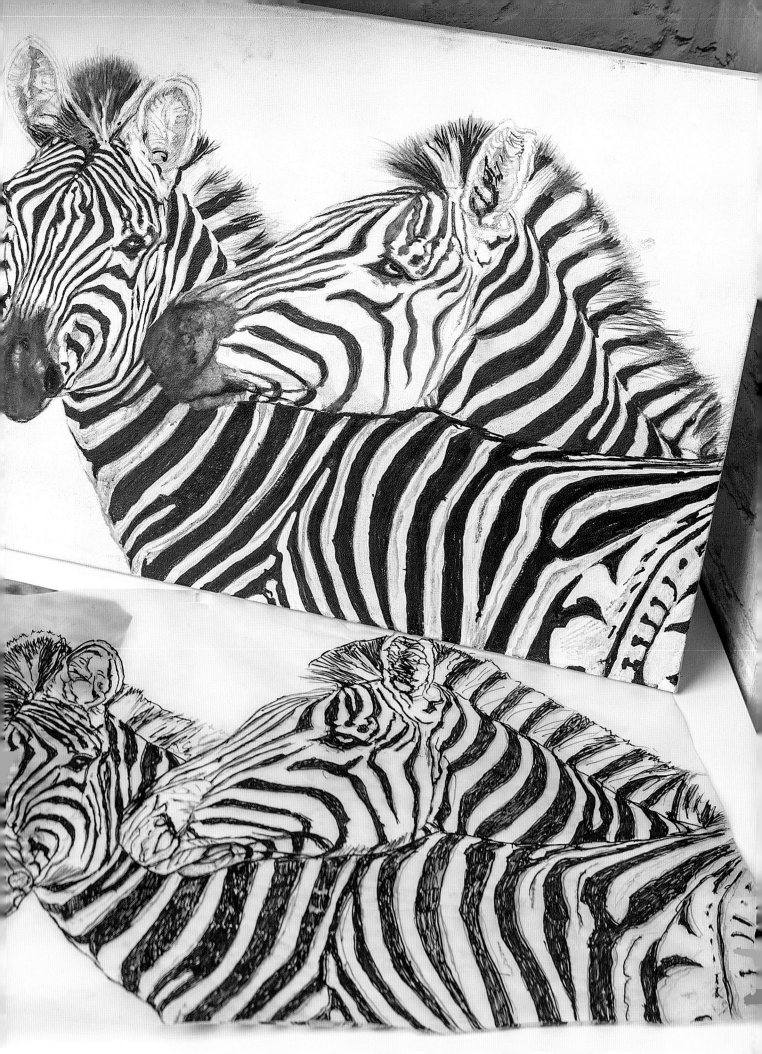

From photograph to first layer

The first stage of any underpainting is to block in the basic shapes.

 Start by making a master drawing of the zebra from the photograph, then transferring it to your surface.

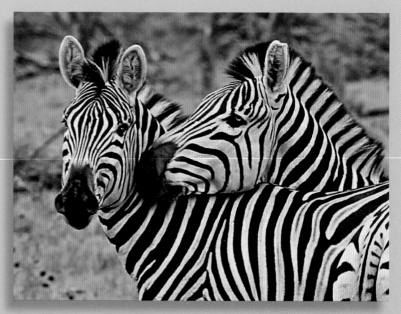

THE SOURCE PHOTOGRAPH

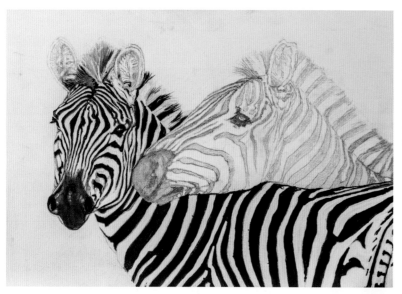

1 Pick up some Inktense pencil colour (Ink black) on the water brush, as described on page 37. Starting at the top, begin to pick out the zebra's hair with fine marks.

The zebras at the start of stage 1. The zebra on the left has had the layer of black completed already to give you some reference for tone as we work through. For this stage we'll concentrate on the second zebra, on the right of the image.

Tip

For dark tones, dab the brush on a piece of clean kitchen paper to take off excess water. A damp brush works better than a wet one for depth of tone.

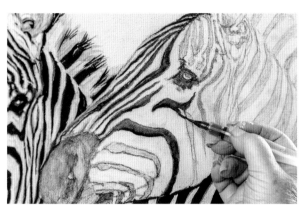

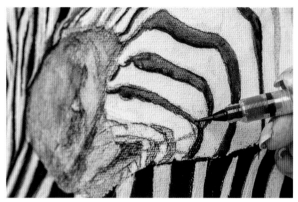

2 Continue building up the dark stripes with Inktense. Aim to get into a flowing way of working, stripe by stripe. Applying the Inktense with the brush pen will give a variety of grey tones (rather than a pure black in one go), which gives you great variety in tonal work.

3 You can build up tone with Inktense by waiting for it to dry, then working back over it.

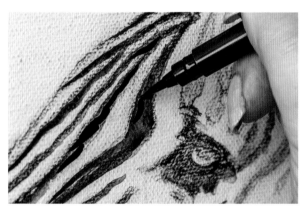

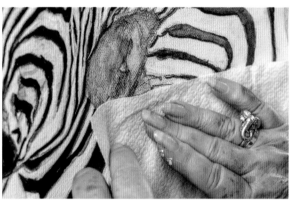

4 Of course, sometimes you want to achieve a particularly strong black, and you can use a brush pen for this. I tend to reserve it for strengthening dark areas that I have already established with the Inktense, usng the pen to emphasize and deepen the tone.

5 Tonking – that is, tapping absorbent paper (such as kitchen paper) onto the damp surface, then removing it – is a good way of removing excess paint. The name comes from Professor Henry Tonks, who pioneered the technique. Tonking will also force the paint a little way into the canvas, allowing you to work with sensitivity. If something seems too dark, try tonking the area before it dries.

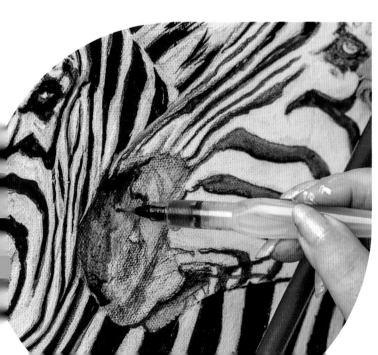

6 The muzzle is a particularly important area, with a great variety of dark tones, so it's important not to simply paint it a solid, dull flat black. Soften the black into a grey with the waterpen, and build up the tones gradually. Refer to the source photograph as frequently as possible as you work.

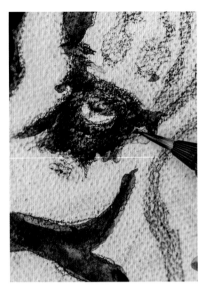

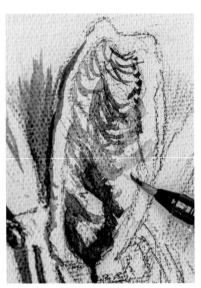

7 Eyes are natural focal points, so work carefully here.

8 Similarly, the texture in the ears – of much longer hairs – requires particular care and attention. Use light strokes and the tip of the brush to apply light tones.

9 For the mane, use longer strokes, again with the tip of the brush. Follow the direction of hair growth.

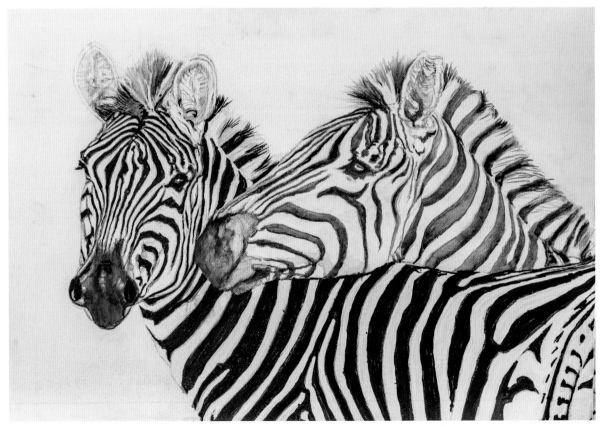

Continue until you've covered all the pencil with dark tones. At this stage, step back and assess where changes need to be made or where tone needs to be deepened.

Developing the tone

For the underpainting to be successful, it must contain almost all the tonal work we want to see in the finished painting. Although the shading on the white is subtle, it is still really important. However well you tone the black stripes, if the white areas are not granted equal attention, the finished piece will inevitably look discordant. You will be working on both zebras in this stage.

For subtle tints, you can make a large pool of water on your paper palette, and dip the brush in after picking up the pencil colour, as shown to the left. This will allow you to add the very pale areas.

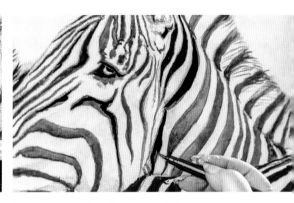

1 The white areas of the fur are not, of course, pure white, and require development to suggest the shape and form of the skin and underlying musculature. Apply the Inktense here well-diluted, with plenty of water.

2 When adding these lighter-toned shadows, try to ignore the stripes – colour over both light and dark areas as one.

3 Swap to the brush pen to build up the tone in the dark areas more speedily – but don't rush. Avoid the temptation simply to 'fill in' the black areas; instead apply the pen within the areas you've already established, leaving some of the Inktense showing at the edges. This will give a much more natural appearance and ensure variety within the blacks.

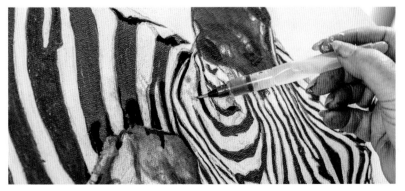

Tip

If it helps you get into the right spot, feel free to pick up the painting and turn it round to work on it.

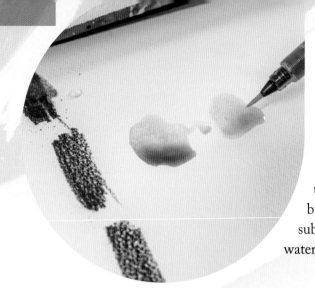

Adding colour

Even at the underpainting stage, we can introduce some colour. Here we use Willow Inktense pencil – a warm, red-tinged brown that is a midway point between raw sienna and burnt sienna to add warmth as well as tone to subsequent layers. Dilute the pencil to a very thin, watery consistency.

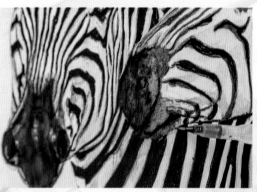

1 Use the water brush to apply the Willow pencil like a glaze over the muzzle areas. Work over the dark areas as well as the light. You will see how this overlaid colour subtly affects the black.

2 Just as we painted the black stripes with a variety of greys that deepen to black, so the white stripes need to be developed more. For this, look closely at your source material, and introduce hints of Willow within the stripes.

3 For the manes, switch to the spiky comber brush if you wish: this will speed things up considerably. Dip the brush in water, wipe off the excess, then pick up Willow Inktense from the paper palette. Use light strokes of the brush in the direction of the hairs, and keep the touches to the tips of the hair.

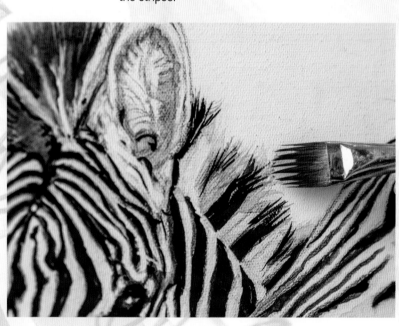

Tip

If you make a mistake, wet a piece of kitchen paper and wipe the error away before it dries.

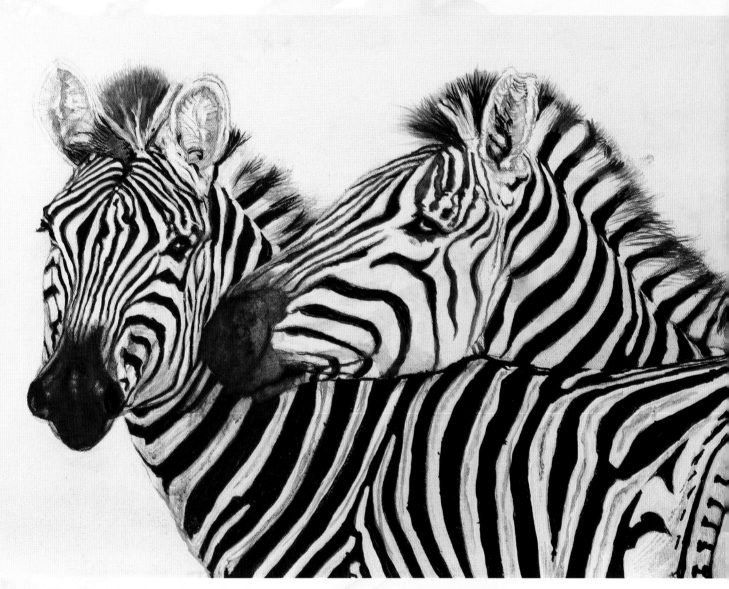

The finished underpainting

Continue adding warm areas, but stop before you overdo things. The later over-glazing with paint will strengthen the effect.

Preparing to paint

Fundamental to the way I paint is the concept of mixing through layering. Rather than physically mixing the paints together, different colours are produced by painting repeated layers of very thin paint over the underpainting – a technique called glazing. Each glaze is semi-transparent, so some of the underlying colours show through. If the same colours are used, the depth of hue and tone grows richer as the layers gradually build up. If different colours are used, you can alter the hue, too. The way I like to explain this is with sweetie or candy wrappers: if you put a transparent yellow one over a red one, then it will appear orange – a mix of red and yellow.

I have refined my painting techniques to combine the depth and smoothness of oils with the fast-drying nature and resilience of acrylics. It relies on the paints and mediums being prepared and used in a particular way, as detailed here.

Multiple layers of paint, alternating between opaque for texture, and transparent for colour, are used to build up the work from the underpainting.

Preparing mediums

Pre-prepared acrylic mediums (see page 17) can be added directly to paints and combined. I have experimented with various mixes to find which work best for me, and now use two main combinations of my own, which I call my number 4 medium and my number 8 medium; named after the proportions of water in each. I make up each in a large jar.

Number 8 medium This is made up of one part flow improver, three parts slow-drying medium and eight parts water. This medium brings out the colours of a painting because it creates a layer of what amounts to clear acrylic paint, allowing more light to penetrate and reflect from the surface. I give the whole canvas a wash of this mix when I want to slow down the drying time of the acrylic paint so that I can work into wet paint. This medium keeps the surface feeling smooth and fluid for around ten minutes, giving me more working time with my acrylic paints.

Number 4 medium Made up of one part flow improver, three parts slow-drying medium and four parts water, this is for slowing down the drying time of paint and allowing more time for adjustments. Effectively, this changes the characteristics of acrylic paints to make them feel more like oils, removing any 'drag' when applying the paint. It gives me twenty to thirty minutes of working time: useful to blend and diffuse large areas of background. I sometimes work in small areas that I want to diffuse or do a wash over the whole canvas. I also mix this prepared medium with the tube colour to put in small areas to blend or feather the paint.

Preparing your paints for glazing

Prepare all the colours you need for a painting before you start. I mix all my colours in this way to create the transparent wash consistency I require for glazing.

Tip
You might find it helpful to add to the jar a sticky label with the name of the paint.

1 Squeeze out a small amount of paint into a clean jar. If you want a thinner mix for glazing use a fairly small amount. Similarly, for a thicker mix, use more.

2 Tip in a small amount of water – it's better to add too little, as it's easier to add more water if it's too thick, than add more paint if it's too thin.

3 Add two drops of flow improver medium to the pot.

4 Use an old brush to stir the mix together thoroughly. It's important that the mix is completely smooth, with no clumps of the tube paint.

5 Top up the jar with a little more water, then put the lid on tightly and shake it thoroughly.

6 Take the lid off and use the mixing brush to test the mix on a spare scrap of paper. If it's too thin, you can add more paint; if too thick, add more water.

Mixing for coverage

Using more paint in the mix gives a good opaque result. This is not suitable for the glazing technique, but is sometimes handy for feathering (see page 124) or other techniques.

In particular, I always prepare two pots of titanium white for a painting. The first is prepared as described above, for a nice flowing semi-transparent wash, while the second pot uses more paint. It is useful for coverage, and vital for effects like fur, as described on pages 116.

My palette

As explained on page 15, I divide my basic
palette into opaque and transparent colours. The following
paint colours are reliable, and form a good starting palette:

Opaque Mixing white, titanium white, Naples yellow, cadmium yellow and buff titanium.

Transparent Burnt sienna, raw sienna, burnt umber, lemon yellow, ultramarine blue, ultramarine violet, permanent alizarin crimson, Davy's gray, pyrrole orange, phthalo green (blue shade), and phthalo turquoise.

I use the palette of colours above for most of my paintings, but as standby I will sometimes
need additional bright opaques for particularly vibrant colours or effects. These include
cadmium yellow, cadmium orange and cadmium red.
It's also worth experimenting. Painting should be enjoyable, so don't feel restricted. Every
so often I find a new colour that I really enjoy using, and it opens up new subjects to me.
My favourite colours at the moment are pyrrole orange, phthalo turquoise and sometimes
phthalo green (blue shade). All three of these colours will really brighten up areas in a
painting when used as a wash or glaze.

Choosing colours for a painting

When picking colours for a painting, I decide on the colour of the main
subject first, then the supporting colours. To help make these
decisions, I find as many colours as I can in the reference
photograph, then I prepare them, as described
on page 47, from the palette of
colours above.

Tiger Cub

YOU WILL NEED

Surface: Prepared canvas, 45 x 60cm (18 x 24in)
Brushes: pointed oval wash brush, small spiky comber, medium spiky comber, 00 rigger, large soft brush
Paints: burnt sienna (thin and thick), lemon yellow, titanium white (thick and thin), ultramarine blue, alizarin crimson, ultramarine violet, raw sienna
Other materials: Inktense Ink black pencil; various palette knives; number 8 medium (1 part flow improver; 3 parts slow-drying medium; 8 parts water) and number 4 medium (1 part flow improver; 3 parts slow-drying medium; 4 parts water)

Art is meant to be creative. It's got to come from within – which is why you have to paint what interests you. Following these stages rigidly will give a regimented result; so I encourage you to use the following pages as advice on starting points, rather than the be-all and end-all.

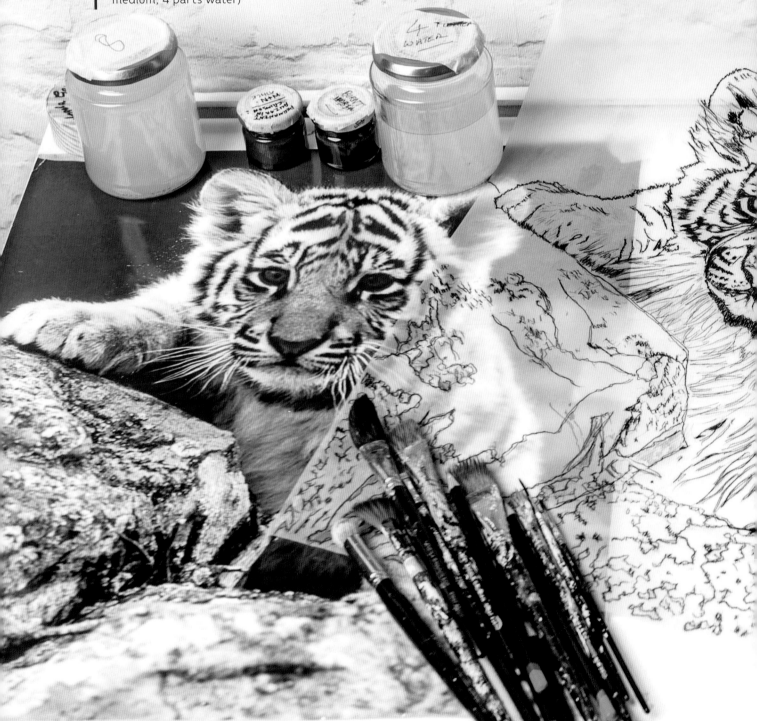

This tiger, like all my work, is painted indirectly. This means that the painting is built up through transparent layers of pure colours. Each layer either adds texture and form (with opaque paint) or colour and tone (with transparent paint). Light can penetrate transparent paint, and bounces back from the layer underneath, giving a beautiful vibrant effect.

Working with pure, unmixed colours in each layer means that any impurities present in the paints don't combine, which can happen when you physically mix them on a palette before applying them. This gives a clean, vibrant effect.

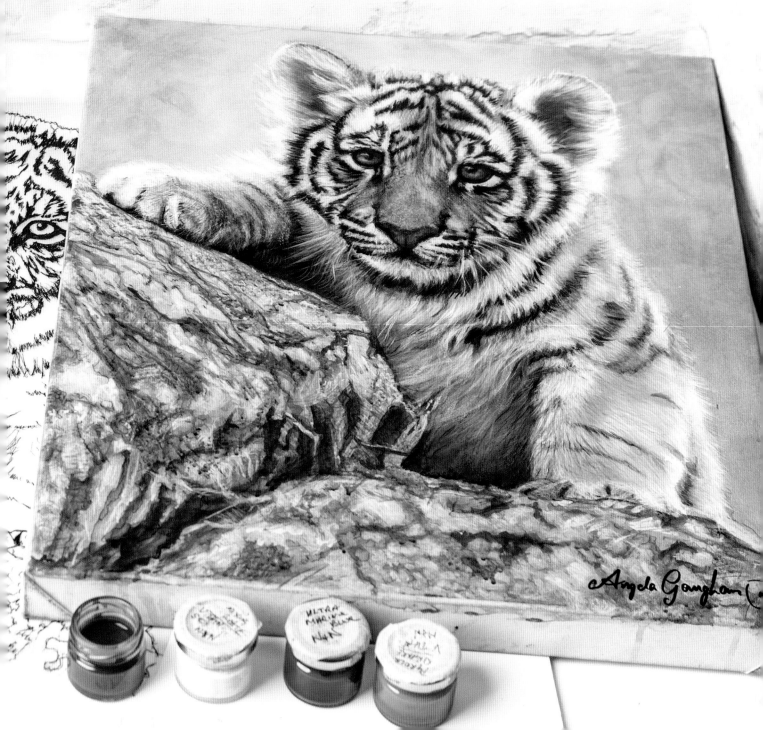

First steps and first washes

Before you begin, produce a master drawing of the tiger cub, as described on pages 30–31. Transfer the drawing to your prepared canvas, then build up the image with the water pen and Inktense Ink black, as described on page 37.

Throughout this stage, work with continual reference to the source photograph, painting just what you see, and without being drawn into interpreting it. Use tonking (see page 41) to knock back the colour if it is too strong.

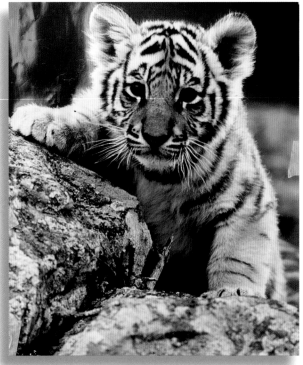

THE SOURCE PHOTOGRAPH

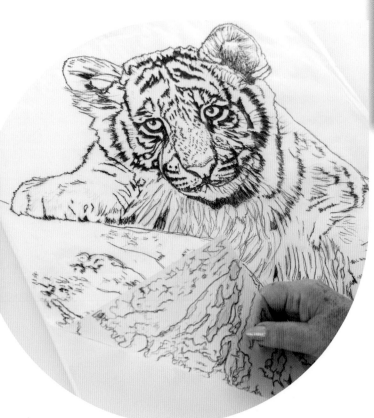

Take your time when transferring the image to the canvas from the master copy, and spend some time reinstating the lines, making sure that everything is in place before you begin.

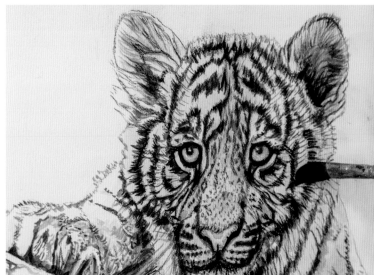

1 Using very diluted burnt sienna, lay in a thin wash over the tiger and rocks with the pointed oval wash brush. This is the first tint. This stage gets rid of the intimidating white, and gives a uniform colour over the whole picture. This is important, as it will marry together the whole painting at the end, giving a certain warmth to the finished work.

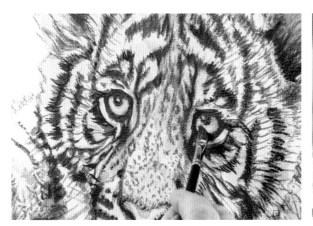
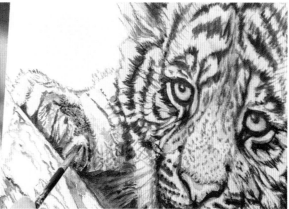

2 Use a small brush – any small brush will do; I used a small spiky comber – to add lemon yellow to the eyes. This is a semi-transparent paint, but because it's diluted so much, it's essentially transparent. Owing to the black underpainting, the yellow layer of semi-transparent paint will look slightly greenish.

3 Allow the paint to dry completely before continuing. Switch to a thicker burnt sienna – note that this is still watery; it's just thicker in comparison with the paint used for the first tint. Still using the small spiky comber, glaze small areas selectively, building up the darker tones.

4 As you continue to build up the warm areas of the fur, follow the direction in which the fur grows to give it body and form. Use the side of the small spiky comber brush for definite marks.

5 Change to the tips of the brush for finer hairs. To help the areas blend into each other, and to prevent different areas being starkly different in tone, you can apply a glaze of clean water before adding the paint. This slightly dilutes the stronger mix.

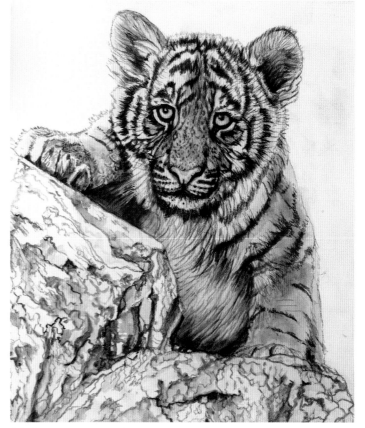

The burnt sienna will appear very bright at this stage – don't worry about this, as the later stages will knock it back. In fact, you want this stage to be very vibrant, as if it does not, the finished result might look rather flat and insipid. Allow the paint to dry completely before continuing.

Opaque whites and initial glazes

With the initial wash in place, we can now start the foundations of the texture. The white marks need to be thick enough to cover the wash, but not too sharp and stark. To achieve this, use a damp brush: dip it in clean water and wipe off the excess before loading it with white. This ensures the paint flows well, and thins some strokes to allow a little of the paint beneath to show through here and there.

Work with close reference to the source photograph. Aim to look at the model more than the canvas – with practice your hand will get used to following your eye, rather than needing to be monitored!

The titanium white used in this stage is opaque and thick – almost buttery or creamy in consistency. This ensures that it has good coverage.

1 Use the medium spiky comber to begin adding the initial white areas, lightly brushing with the tip of the brush to create the fine white hairs while leaving some of the burnt sienna showing through.

Tip

You can use gesso in place of titanium white paint for this stage. Gesso doesn't sink into the surface so much as paint, so it is good for creating subtle additional texture and helping following layers to adhere. It is also useful if the canvas surface is slightly slick (as happens with some primers), as it contains adhesive.

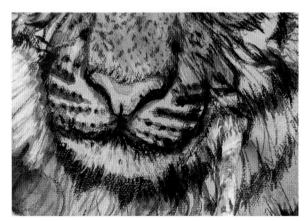

2 Change the part of the brush you use to add the opaque white to reflect the texture of the fur. Around the muzzle, the short, fine fur is best produced wth stippling – using the very tips of the bristles. The ears require longer strokes with a gentle curve, so the side of the brush is better suited in this area.

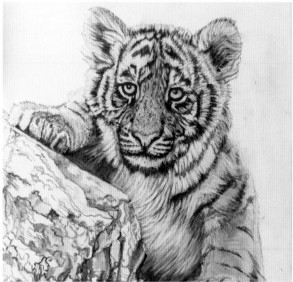

3 Continue to build up the white across the tiger. Strike a balance between adding texture and light, and in allowing some of the underpainting to show through.

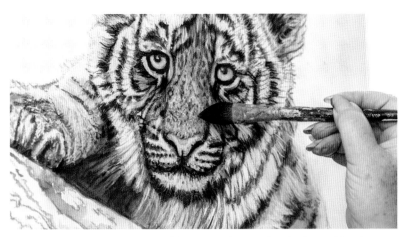

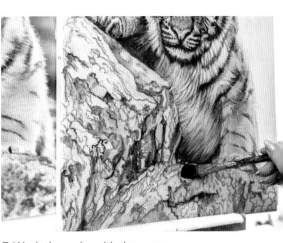

4 Use very watery ultramarine blue to work over the shadows. Blue is a good colour for shadows, giving a relatively cool finish against the warm orange of the tiger's fur. Apply the paint with a damp pointed oval wash brush. At this stage, I'm thinking about shadows because they help to build up the form. Refer to your source photograph and avoid putting blue on the areas of highlight. Concentrate on building up a sense of light.

5 Wash the rocks with the same dilute ultramarine blue. I like to incorporate the colours used in the subject in the background, too. It helps to give a harmonious feeling to the overall image.

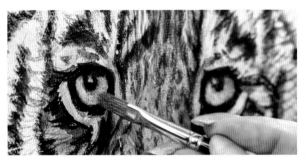

6 Swap to a small spiky comber and use burnt sienna to glaze the eyes. Rinse and dry the brush, then lift out a little of the wet paint at the lower left. Allow the painting to dry.

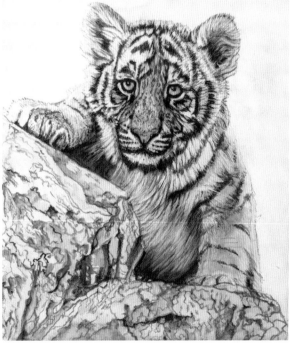

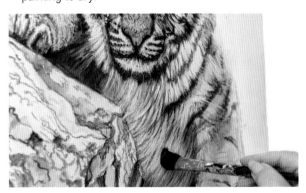

7 Use alizarin crimson to glaze the nose and warmer shadows, such as the lower right of the tiger's belly. Wipe the brush on kitchen paper to take the remaining paint off, then use it to wipe over the wet paint and lift off a little alizarin crimson. This will soften any edges for a smooth result.

To finish the stage, use lemon yellow and the pointed oval wash brush to wash over the whole background. Work quickly and overlap the edges of the tiger and the rocks. Lemon yellow, being slightly green-tinged, recedes into the distance. In turn, this makes the warm tiger cub appear to advance towards the viewer.

Building layers

Once the initial glazes are dry, you can see the brightness of the first stage, and the opaque whites have been knocked back somewhat. This is the start of refining and enriching the colours and texture through repeated layers. This second white layer is not a duplicate of the previous one; rather you are emphasizing some of the previous white areas.

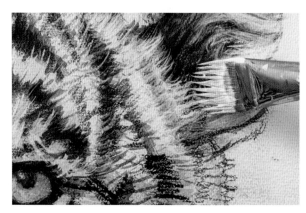

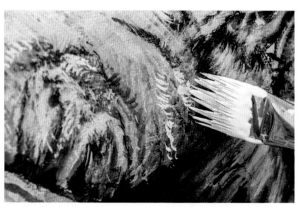

1 Add another layer of titanium white, as earlier. Pay careful attention to the direction and length of the fur in the area you're painting – refer to your source photograph frequently.

2 The aim is to complement rather than cover the previous layer of white, so work carefully to build up the white and suggest fluffy fur, leaving some areas of fur sparse, spiky and dark.

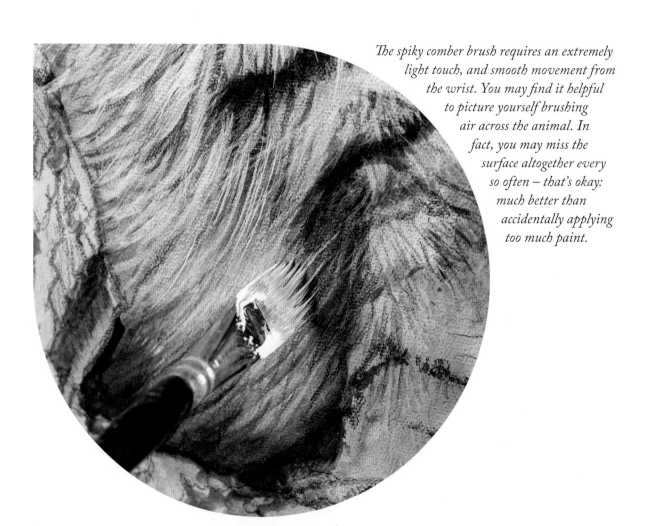

The spiky comber brush requires an extremely light touch, and smooth movement from the wrist. You may find it helpful to picture yourself brushing air across the animal. In fact, you may miss the surface altogether every so often – that's okay: much better than accidentally applying too much paint.

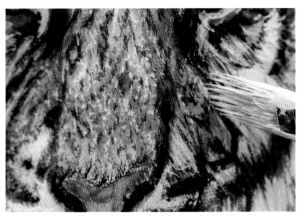

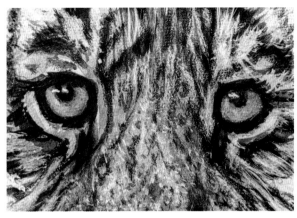

3 Use the tips of the brush for the very fine, short hairs on the nose, a process called stippling.

4 At the end of this stage, use the 00 rigger to touch in highlights on the eyes – a dot in each, and a small stripe on the left-hand one (the tiger's right) as shown.

Don't be afraid of how bright the white marks appear as you build them up, as we will glaze over to soften them, then build them up again repeatedly over the course of the painting. In this way, the layers will build up over time, enriching the colours and giving the image more and more depth. It is therefore important to remember to use transparent washes and to use complementary strokes of opaque paint, rather than copy previous layers of white.

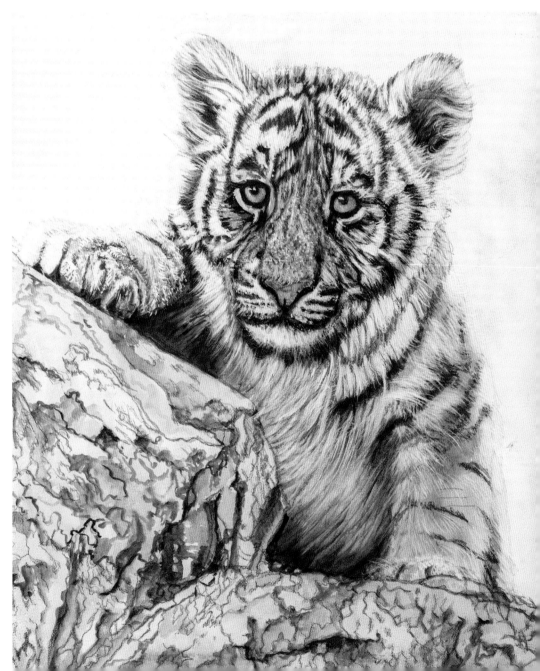

Refining

As the layers build up, you start to create enough tone and colour to correctly judge details like the animal's features, so this stage makes the most of this. Having some more developed features then, in turn, helps inform the later layering.

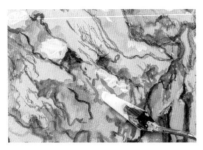

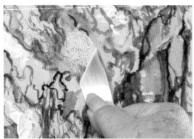

1 Add some texture and highlights on the rock using the palette knife, picking up the paint on the edge and depositing it with light touches.

2 Scrape the blade of a clean palette knife over the surface to develop the texture.

3 Swap between different palette knives to more easily build up a variety of hard marks on the rocky surface.

Tip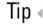

You can also use this technique to remove a little paint, if you feel you've added a little too much.

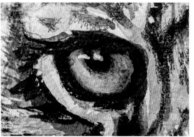

4 Swap to the small spiky comber to paint another glaze of burnt sienna over the right-hand sides of the eyes, to warm and strengthen them. Follow the form of the eye, suggesting the curve of the eyeball.

5 Touch in a hint of ultramarine blue over the upper eyelids, extending it over the top of the eyes.

6 Allow the blue paint to dry, then add a tiny hint of alizarin crimson at the top right. This suggestion of warmth draws the viewer's eye to this focal point, and really captures their attention.

Tip

You can use a hairdryer to help speed up drying times between layers, but use it on a cool, slow setting. When testing to see if an area is dry, use the back of your hand, rather than your fingers. This helps to ensure that you don't get any oils from your fingers on the surface.

 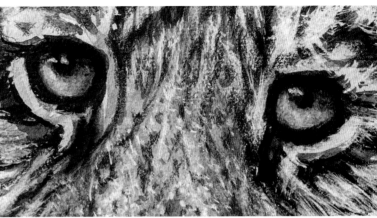

7 Still using alizarin crimson, glaze the nose. While it remains wet, lift off paint to create highlights by rinsing and drying the brush, then touching the tips of the bristles to the wet paint. Lifting off creates more subtle gradation between tones than layering paint, as some of the remaining wet paint flows back into the edge of the area you have just lifted out.

8 Return to glaze the top of the eye with ultramarine blue once more. This time, work right over the highlights as well – this tints the white and suggests the reflection of a blue sky.

9 Swap to the mop brush to paint a thin wash of ultramarine blue over the rocks, bringing some colour back into the area and softening the highlights a little. Build up the tone in the shadows with stronger blue paint, lifting out areas to further develop the texture. Swap to ultramarine violet, building up glazes on the rocks on the left and the shadow areas of the tiger itself. Allow to dry.

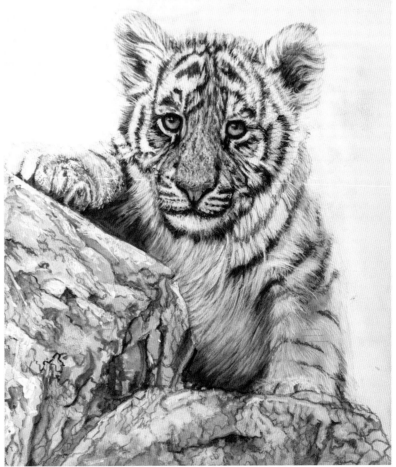

Building depth

Here, we use repeated, alternating layers of pre-prepared medium and paint to build up to a silky, satin finish.

You can achieve wonderful subtlety through painting into the medium. This is a time-consuming – but very enjoyable – stage. Aim to get into a natural flow and work around the painting instinctively. This is one of my favourite stages of painting, as the surface feels wonderfully smooth to work into.

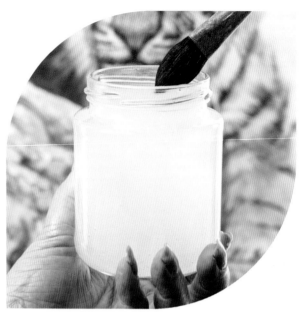

Number 8 medium (made up of one part flow improver, three parts slow-drying medium and eight parts water) slows the drying time of the paint right down, allowing you to enjoy the process. Painting into number 8 medium keeps the fluid paint we're using where it's placed. In contrast to using water, which wicks away and diffuses the paint, the medium holds onto the pigments somewhat. This allows you to create soft texture where you want to, as the paint will neither bleed away nor create hard edges.

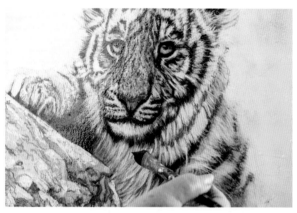

1 Paint a layer of my number 8 medium over the whole painting, using the pointed oval wash brush.

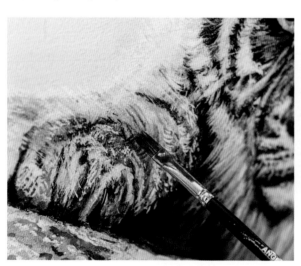

2 Switch to the small spiky comber and pick up burnt sienna. Use this to begin developing the warmth of the fur. Painting into the wet, glossy surface feels more fluid, and reduces the appearance of brushmarks.

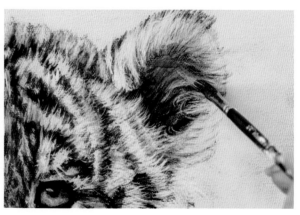

3 Continue working round the tiger with the small spiky comber and burnt sienna. The number 8 medium will remain workable for around half an hour; after which it will start to feel a little tacky. If you want to continue working with it, allow it to dry completely (you can hurry things along with a hairdryer) and apply another layer.

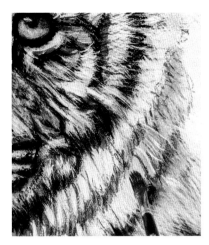

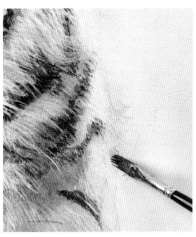

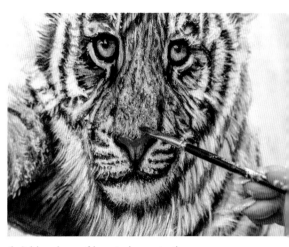

4 As you work over the dark areas, note the depth. The black of the underpainting is providing the depth of tone, but it is overlaid with a number of subtle glazes of colour that add richness.

5 At the edge of the white fur against the background, add a hint of burnt sienna. This creates a warm halo around the tiger and adds to the impact of the fur.

6 Add a glaze of burnt sienna to the nose, to knock back the brightness of the red here. Overlay a little blue on the muzzle, too. This is the complementary colour to the orange here, which means that they neutralize each other, giving a slightly greying effect.

Tip

Tonking (see page 41) is a useful technique to use in concert with the medium, as you can use pressure sensitively to tap colour out, without leaving obvious marks.

Use ultramarine blue to selectively glaze areas of shadow, subtly greying the colour here and there. You can continue for as long as the medium remains fluid – and even then you can add more and repeat the process. The more glazes and layers you build up throughout the painting, the richer the result.

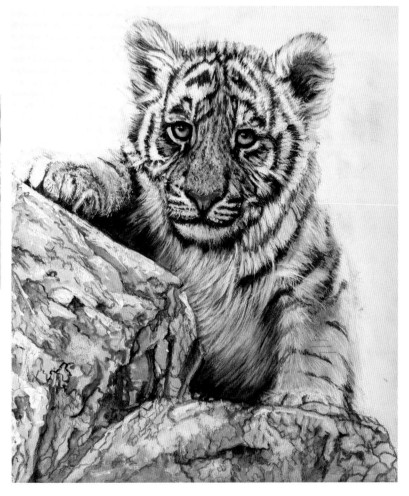

Finishing

This stage rewards patience. While the main aim here is to add a simple background, you can add some further highlighting to the fur with titanium white and the small spiky comber while the medium remains workable. The more layers, the richer the finish.

1 Use the pointed oval wash brush to paint another coat of number 8 medium over the surface, then glaze the background with ultramarine blue.

2 Using the large soft brush, make small, light swirling motions to blend and diffuse the layer. The brush should be dry, and your wrist very loose to feather the paint (see page 124 for more).

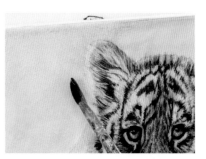

3 Once the blue has been feathered into the background, use the small spiky comber to apply small marks in titanium white, ultramarine blue and some warming touches with burnt sienna – incorporating colours from the tiger helps to harmonize the background with the subject.

4 Diffuse the marks with the large soft brush, feathering them in to build up a variegated surface across the whole painting.

5 Once dry, use the pointed oval wash brush to add a very dilute glaze of raw sienna to the background to warm it a little. Draw it down over the animal and the foreground rocks, to help integrate the background and subject.

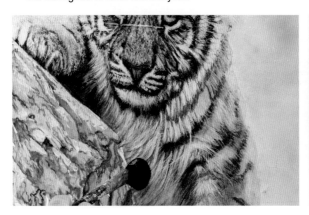

6 Allow to dry completely, then use the pointed oval wash to lay number 4 medium all over the subject. With much less water in it than number 8 medium, this has a more gel-like consistency and dries much more slowly. This makes it ideal for the final stages.

7 Use the 00 rigger to begin to pick out the finer details. This stage can take a long time, so get comfortable and settle in. Step back every so often and critically evaluate the painting, and be ready to declare it finished. You can always return to refine further, after all.

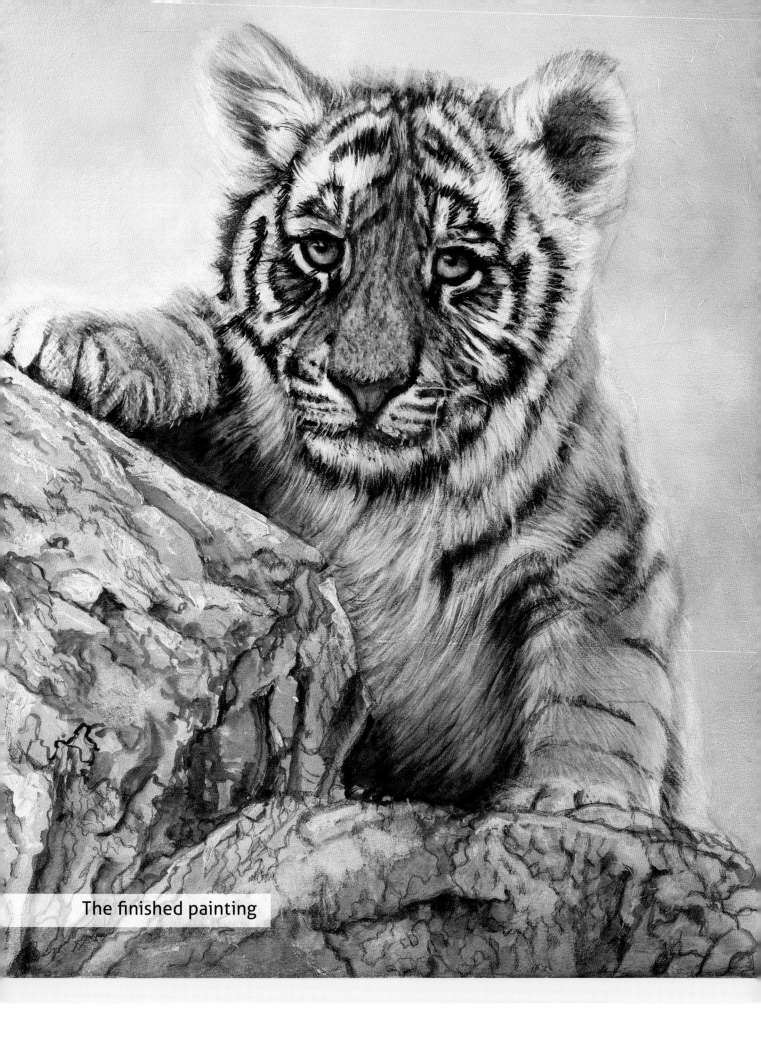

The finished painting

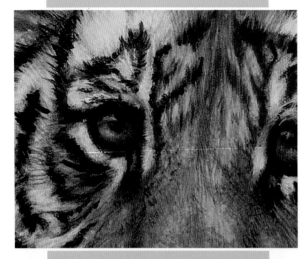

Going further

The demonstration on the previous pages was completed in one day, as a demonstration of the techniques that I use to produce a painting. The picture on the previous pages was as far as I could take it in the time.

To refine it and bring it to the level of finish shown here took a lot longer. Once back in my own studio, I kept building up the layers of paint as I did on the previous page until I was satisfied with the finish. I glazed the eyes again to darken them and also darkened both the background and the shadows.

You might similarly wish to carry on and take the techniques on your own painting further. Repeating the layers and glazes will result in an increasingly complex and satisying result, so build and build until you are satisfied.

One of the great strengths of these materials and techniques is that there is no fixed end point. I like to live with a painting for a while before signing it off and considering it finished; so when you think the painting is done, set your brush down and try not to think about the artwork for a week or two. When you come back, you will either see areas that you wish to refine further, or a satisfying finished artwork.

Young Tiger Cub 45 x 60cm (18 x 24in)
The finished painting is now in the private collection of Mrs Gini Morrison.

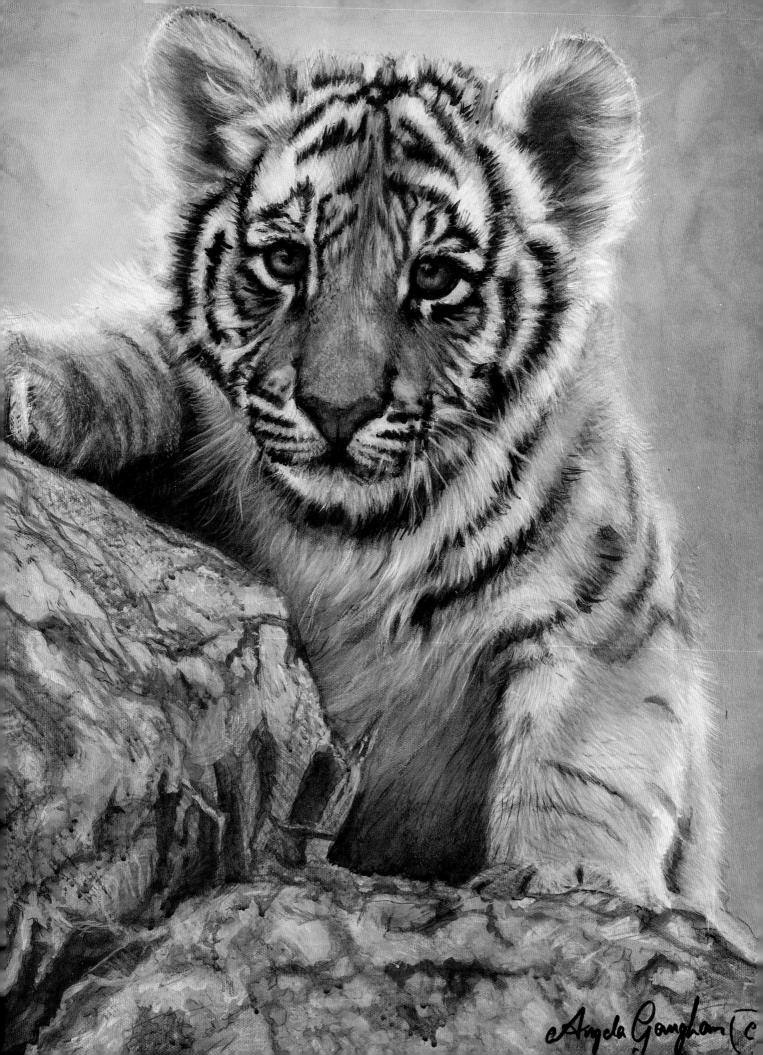

Angela Gaughan ©

Creating your own paintings

Now that you have seen how I work, it's your turn. Even if you have never painted animals before, take a chance – try something new. The more we challenge ourselves, the more we learn and the better our artwork will become.

This part of the book looks at the challenges and opportunities of creating your own artwork, from working out what to paint to creating a solid plan from which to work – and then on to the practical techniques you can use to bring your vision to life. A little bit of preparation will do a world of good, and allow you to create finished artworks that are more personal to you. After all, first and foremost, we should paint to bring pleasure to ourselves.

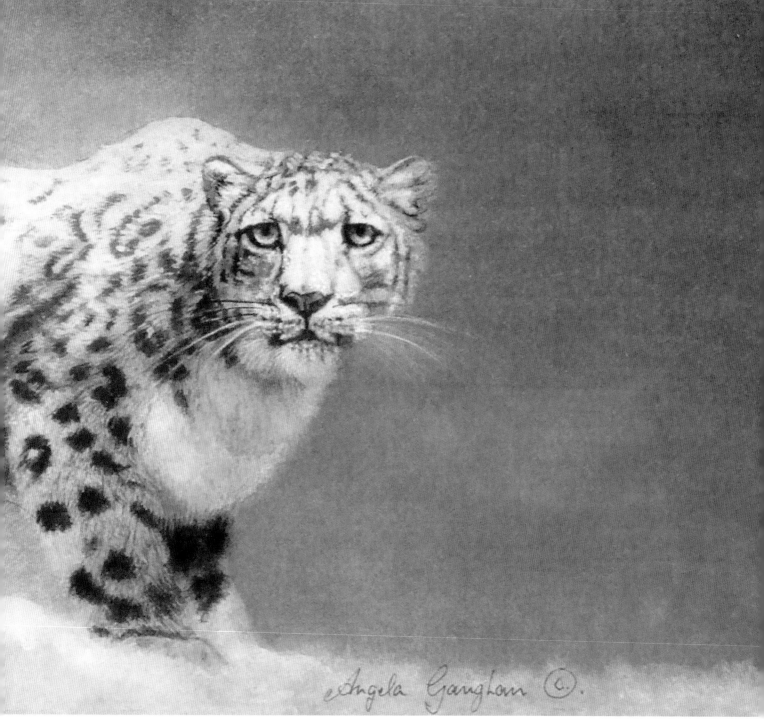

Snow Leopard

61 × 39cm (24 × 15½in)

This snow leopard was painted in watercolour. Despite being relatively small, the artwork packs a punch. The prowling leopard turns to look at you, against a colourful, dramatic sky that sets off the subject. Note that the darkest part of the sky is behind the head: this ensures the maximum possible contrast between background and leopard, throwing this focal point forward. I vividly remember the enjoyment of dropping colours into the sky and watching them bleed into one another.

what to paint?

Lots of people say to me that they don't know what to paint – I tell them to paint whatever's in front of them. I often get asked where I get my inspiration, and usually it is nothing more complicated than keeping my eyes open. I see paintings in everything I look at, but I think that has come from many years of developing my observational skills. If you aim to develop this habit, you too will start to see the painting opportunities that surround us all.

More than anything else, I would advise you to paint what inspires you, whether it is animals, flowers in your garden or a landscape. Whatever it is, really take time to observe everything in front of you and paint what you see; what you want to capture. Time spent in this way can be very rewarding and satisfying.

I don't think of myself as a wildlife artist; rather I have always simply painted what I wanted to. Although most of my artwork today is of animals, that is because I really enjoy the challenges and opportunities that painting fur gives me.

Whatever you wish to paint, it is important not to get tunnel vision. Studying and painting other subjects will help you to become a more well-rounded artist, and will certainly improve your skills when returning to your favourite subject.

To help illustrate this point, I have included a number of other subjects in this part of the book – people, flowers, and buildings, amongst others – to show you how particular concepts and techniques can be applied universally, and to your animal artwork in particular.

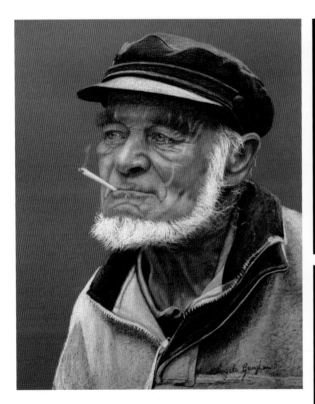

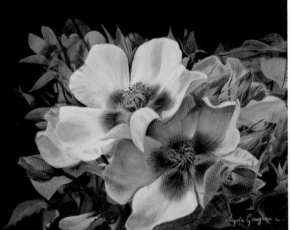

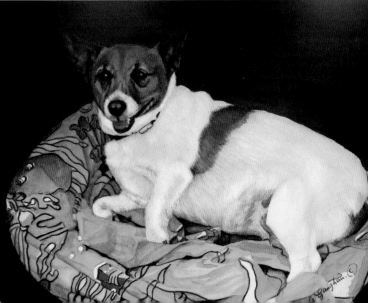

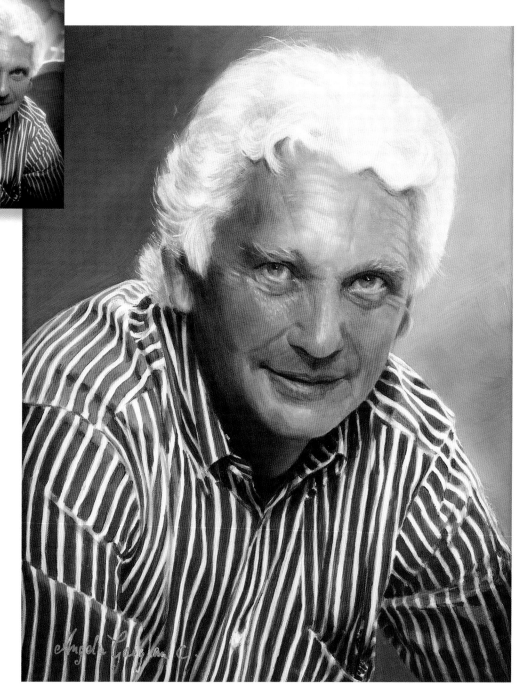

THE SOURCE PHOTOGRAPH

Mike

41 x 51cm (16 x 20in)

The lessons you learn from different subjects will inform and improve your abilities, which is why a personal connection is vital.

This portrait of my husband Michael was painted from a photograph taken on a cruise ship on which we were teaching art. I wanted to focus on his eyes – just as I do with my animal paintings – and so for the background I chose soft shades of grey-blue that match his eyes.

Finding inspiration

A painting might be triggered by a sudden moment: a flash of colour; the shape of an animal, or the play of light on a landscape. That is why it is so important to keep a sketchbook or camera handy: you can jot down ideas before you forget them. These ideas are precious and fragile and, like dreams, easily forgotten.

You might also be inspired by a photograph, a lighting effect in a particular composition, or a trip to an art gallery. You do not need to copy the work of others to be inspired by their art. Inspiration is subjective. An exciting subject for one artist may not be worth a second look for another. Even if you do not turn your ideas into new paintings, they can be incorporated into existing ones.

For me, my inspiration comes from a lifelong study and observation of colour and light. When I am out and about, I am always looking for likely subjects. Even sitting in the garden with a coffee, I am unconsciously looking for things to paint. Let your gaze drift and paint what you see. Seeing fully leads to deep appreciation, understanding and gratitude. These qualities can make the ordinary subject into extraordinary beautiful art.

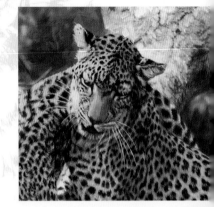

'First and foremost, we should paint to bring pleasure to ourselves.'

Every painting in this book gave me enjoyment during the process of painting, and all continue to give me pleasure now they are completed and displayed. Painting is a journey on which you never stop learning – and that is, itself, part of the enjoyment of art.

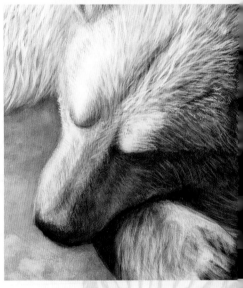

As you get older, you really start to appreciate nature and the beauty in nature and animals. It is always there before us waiting for our attention. All you have to do is open your eyes and paint what you see – and what interests you.

What I want you to take from this book is the practical knowledge and techniques that will enable you to paint the subjects that excite you most – only in this way will you produce artwork with which you fall in love. Whether you choose to apply the lessons to painting animals or portraits or landscapes is irrelevant: the key is to learn to see as an artist does.

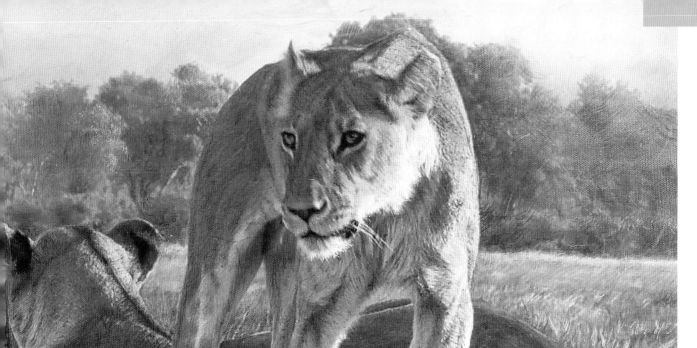

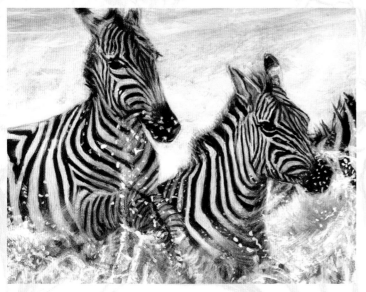

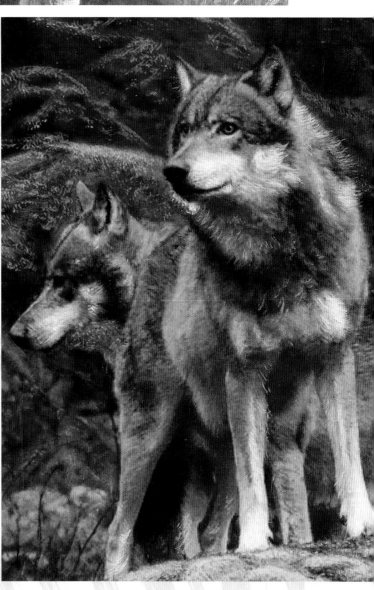

Trust your eyes

Nature is full of colour. The more you paint, the more you start to see. Observation trains your eyes to really see the form, details and colours of objects. I often tell my students when they are painting green foliage to switch off the brain and really see the colours they are working with; to look for the yellows, blues and reds.

Start by looking around you. If you are at home, look at some nearby objects such as the cup or mug from which you're drinking. Such everyday items are easily overlooked – they're so familiar, they tend to fade into the background. From these, you can try setting up a simple still life.

Starting with such simple, familiar objects is a good way to start really looking. What shape is it? What colour is it? Is it plain or has it got a pattern? Take a pencil and start to draw the simple object. Keep your observations in mind, and you will soon see it's not very hard.

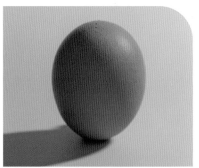

Simple forms and switching off

A good starting exercise is to put an egg on a table and draw it at different angles, as shown here. Switch off your brain and draw what you see. On the face of it, it's a simple oval; but it's also a curved form, with a smooth surface that changes in value from light to dark. Study your object closely, and practise your drawing.

Now you have started observing items around your home, try the same exercise with your pets. They are good subjects to get you started – they won't get shy or object to being drawn! Waiting until they are at rest will make things easier, but sketching them while they are awake will help you to practise capturing things quickly; looking for the vital parts that really capture the subject in front of you.

This exercise is all about getting you to start really seeing things around you. To be an artist you have to be adept at observing things around you.

Take a moment and just watch, pay attention to the little things in life. As an artist you are not painting what your brain tells you is there, but what your eyes alone see. It's a pile of rocks to some people, but as an artist you are free to bring every aspect of what is in front of you into what you paint.

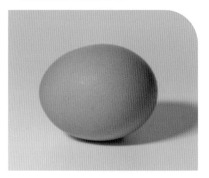

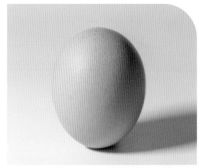

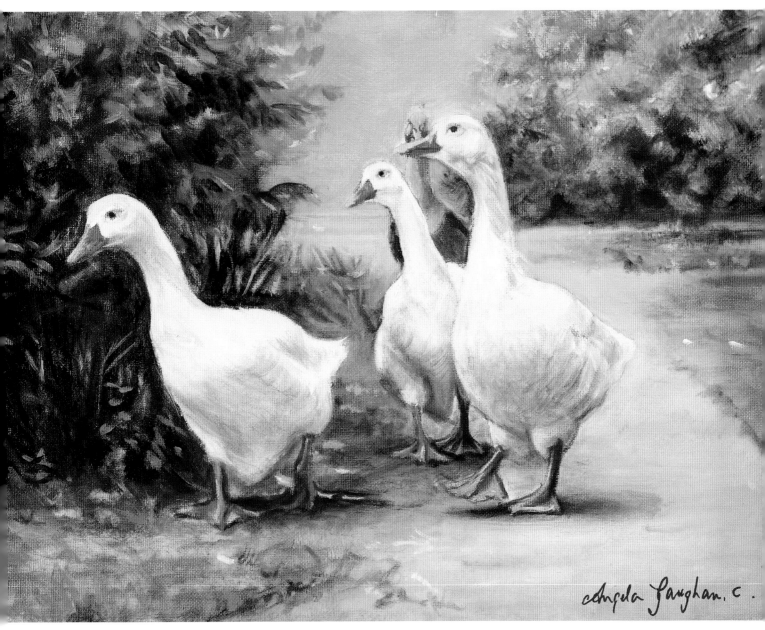

Morning Stroll

41 × 30cm (16 × 12in)

The first painting I ever painted regarding nature was this little painting of geese going for a walk. I would probably not have painted it if I hadn't taken the photograph. I enjoyed painting it so much that I started looking for more reference on landscapes and animals; and so the journey started.

So never say you don't know what to paint. Start looking around you, go out into the garden, watch the birds, flowers and butterflies. Start really looking – good paintings start with what you see.

'Take a moment and just watch; pay attention to the little things in life.'

Emotion, mood and atmosphere

A painting is a form of communication conveying a message or telling a story, even if it is only the look in an animal's eye. Many paintings never get beyond raw demonstrations of technique. They are well-painted, because the artist has learned the technique of painting, but the results are ordinary. They are simply pleasing pictures, because the artist has lacked a personal response to his or her subject. Technique without emotion is empty, and results in paintings that look lifeless.

When I speak of emotion, I mean the artist's emotional response to the subject. Creating an exceptional painting with mood and impact, one that makes the viewer stop and take notice, goes far beyond technique. For this reason alone, it is important to paint something you are passionate about. That is how you are going to put life into your art. Feelings make an experience stand out, make it special; and painting is about feelings. After all, if you feel nothing for your subject, why paint it?

To find your subject, spend time with your subject. Get to know it. In portrait painting, you get to know your subject by sitting with them and coming to understand their personality. A likeness is not enough; you must capture and show some of this inner self. In my portrait of my husband Mike on page 69, I wanted to to portray his inner self. A kind, shy and gentle man, I wanted these qualities to shines through in his eyes. In *Nightwatch*, I wanted to portray something of the curiosity of the cat. His eyes, therefore, are trying to work me – and the viewer – out.

The paintings that end up intriguing me most are the ones I get lost in. When I'm painting, I lose a sense of time and begin to explore the world I am creating. It's not so much in the act of painting as it is in the ongoing search to find my subject through mood, texture and colour.

THE SOURCE PHOTOGRAPH

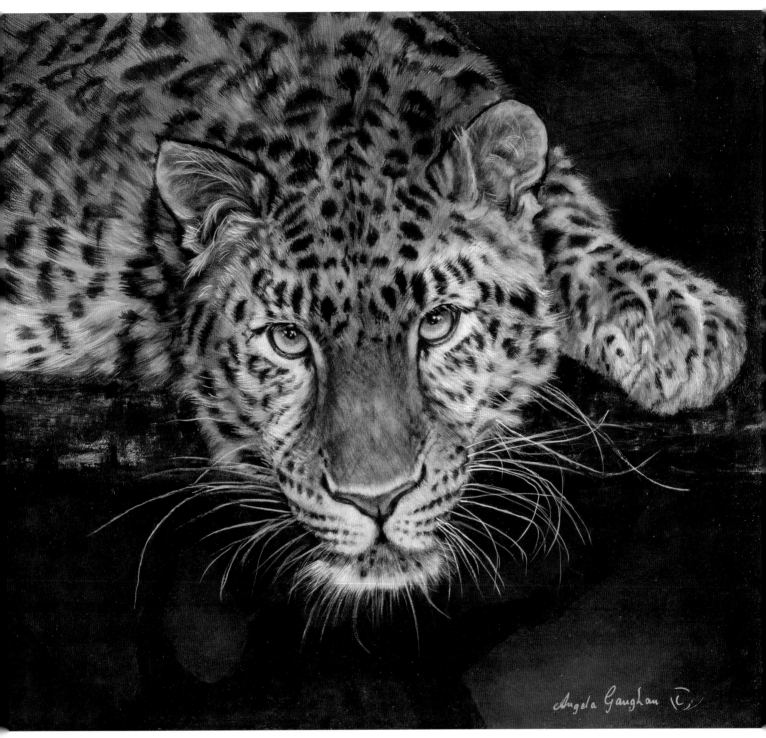

Nightwatch

91 × 61cm (36 × 24in)

The dark blue background used here helps to suggest the night, instantly creating a sense of time and place. Most of the detail is in the leopard's face, drawing you to his beautiful green eyes, around which the entire painting hangs. His arresting gaze forms the main focal point, showing his curiosity in the viewer. I also worked up his fur colour to be more dynamic against the blue. I loved painting this and hope my emotion and passion for this beautiful animal shine through.

Interpretation and a personal response

No matter how photographic, precise and realistic a work of art is, it is not a literal translation of reality. The artist's interpretation is what makes a painting special. Perhaps the artist changed the lighting, colours or moved something; maybe the brushwork or style of painting added individual flair. If you compare a great painting with the actual scene, not only does it look different, but the painting looks better, owing to the artist's interpretation and practical decisions. When we see a great painting, we are moved by such intangibles as good brushwork, rich colours and powerful compositions.

A good wildlife painting is more than a good depiction of an animal or just a pleasing picture, it should have spirit: something from within that the artist feels passionately about and which they share with the viewer.

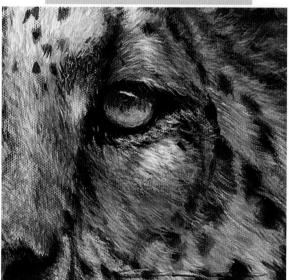

Snow Leopard Portrait 48 x 69cm (19 x 27in)

This piece won me the 2017 David Shepherd Award for the best work depicting an endangered species. It contains a lot of details that I particularly enjoy painting – fur in various lengths and colours, and arresting eyes. Without enthusiasm and love for your subject, painting might be a chore; and without a connection and creative interpretation of the subject, you are just reproducing a photograph. Aim to develop your relationship with your subject to make painting a creative pleasure.

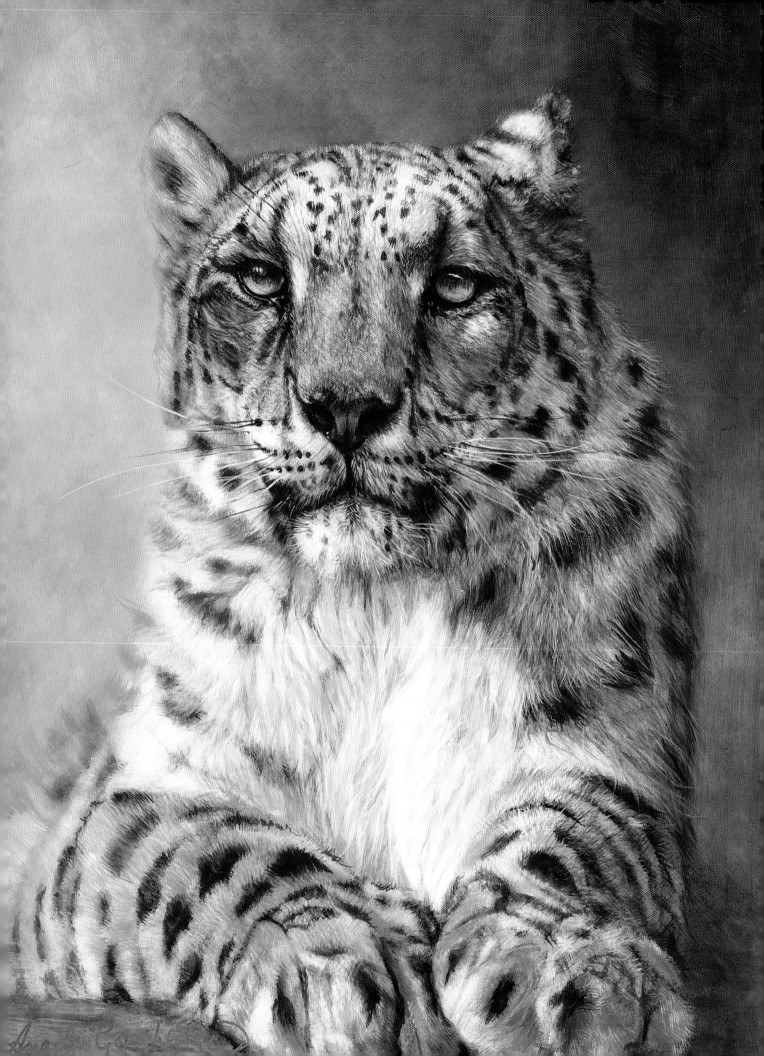

Colour and light

Whatever the subject, all painting relies on the artist's use of colour and light to be successful. Along with the underlying composition, colour and light interact to create the interest and mood of the scene – and the way an artist uses these aspects of the painting can direct the viewer's eye around the painting in a particular way, leading the viewer through the painting.

In general, I aim to represent the world as I see it, accurately reflecting the colours that are in front of me. A balance then has to be struck between reality and artistic choice – sometimes adding some subtle vibrancy with bold colours or muting a less important background area will help to draw the viewer's eye to the focal area. Such changes can be made to suggest a particular feeling, or simply to brighten up a dull day.

You should also feel free to have fun. I believe colour can be very therapeutic. Put simply, using cheerful colours can cheer you up!

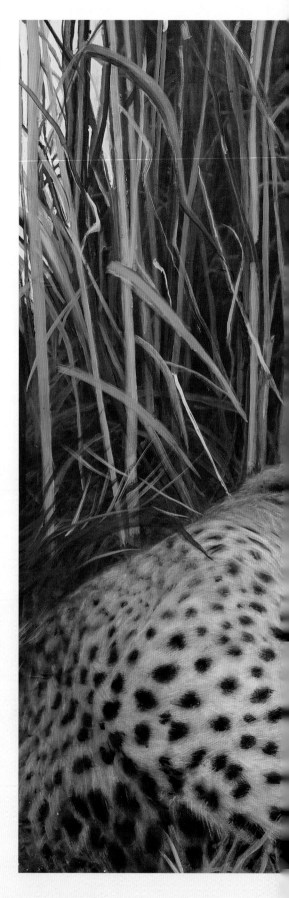

Lookout
104 × 79cm (41 × 31in)

The soft, cool background ensures the cheetahs are the main focus in this atmospheric painting. Half-concealed in the grasses, the warmth of their fur draws the eye, as does the high-contrast nature of their markings. The light is soft, with no harsh shadows, suggesting these cats are scanning the plains in the early morning time – but the colours, along with their relaxed postures, help to ensure the mood is not threatening. These cats look calm and confident.

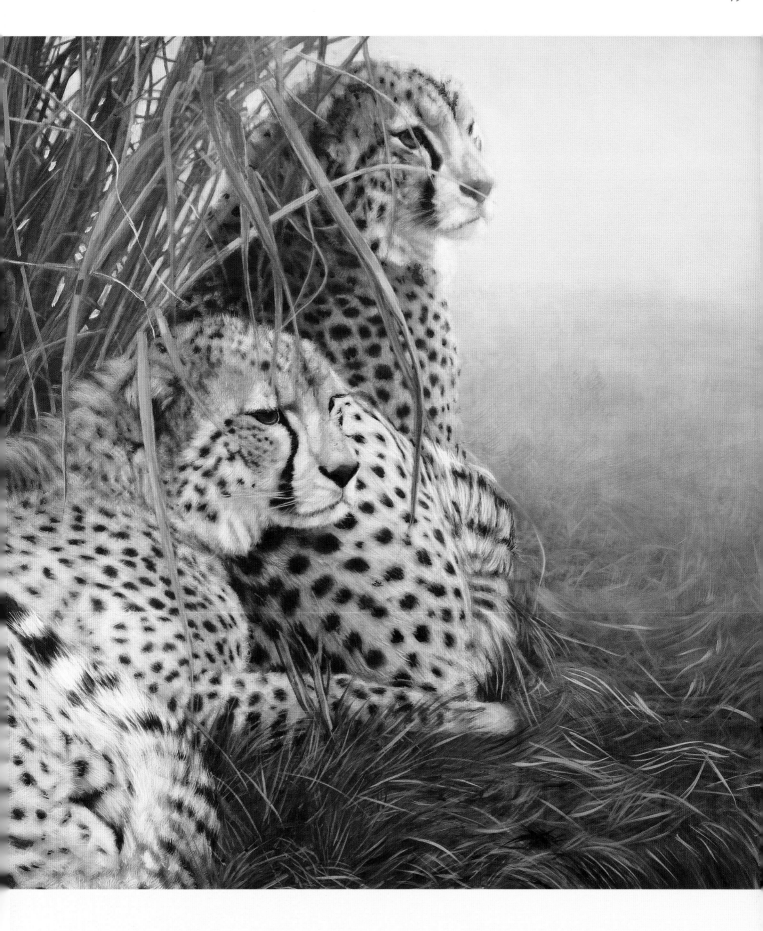

Colour relationships

Colour theory is a rich and complex topic, but it is one with which we are all naturally familiar, so there's no need to be intimidated by it. The colour wheel below is a useful way to illustrate different ways of using colour effectively in your painting.

The colour wheel is made up by placing areas of the primary colours at equal distances apart. Primary colours cannot be mixed from any others. They are red, yellow, and blue. Between these areas, you then add areas made up of mixes of the neighbouring primary colours. The resulting combination mixes are the secondary colours – orange (red and yellow), green (blue and yellow), and violet (red and blue).

You then fill in the blanks to create further mixes, as shown below.

Complementary colours

Complementary colours may also be called 'opposite colours', because they lie opposite one another on the colour wheel. Yellow is opposite violet, for example, meaning that these are a complementary pair.

When combined or mixed, complementary pairs cancel each other out and result in a neutral grey mix. When placed next to each other on the painting surface, however, they create the strongest contrast for those two colours – red, for example looks particularly vibrant next to its complementary, green.

We can use this information to help us choose colours for contrast and impact.

The colour wheel
Colours that lie directly opposite one another are complementary pairs.

Clematis 'Josephine'
69 × 46cm (27 × 18in)

Different pairs of complementary colours are used in this Inktense pencil piece. The clematis petals are red-violet, and are set against yellow-green petals. Note that occasional blue-green petals are included, too. This helps to give a natural appearance. These blue-green areas also complement the red-orange background, helping the picture as a whole hang together.

Harmony and contrast

Painting a picture with a limited palette can create a striking image, with a sense of harmony. Try using four colours from the colour wheel that are next to each other: yellows into greens, blues into purples, reds into oranges.

Sheba
30 × 41cm (12 × 16in)

I was setting up a still life in my studio when my cat, Sheba, decided she wanted to get in on the picture and sat down in front of the orange vase. I loved the contrast of her blue black fur against the orange vase. To keep Sheba as the main focus I kept the colours in the background harmonic; the warm orange in the light cooling in the dark purples. To tie it all together I put in an artificial lily in similar colours, compositionally forming a pyramid that lead to the focus: Sheba's eyes.

Sometimes a painting happens on its own. If Sheba hadn't come and sat down in front of me to try to get my attention, this quick little painting might never have been. Remember then: although most paintings are planned, if you keep your eyes open, artworks can take on a life of their own.

La Belle Femme
67 × 55cm (26 × 22in)

Watercolour. This painting uses only colours from a tight region of the colour wheel, centred around warm reds and oranges.

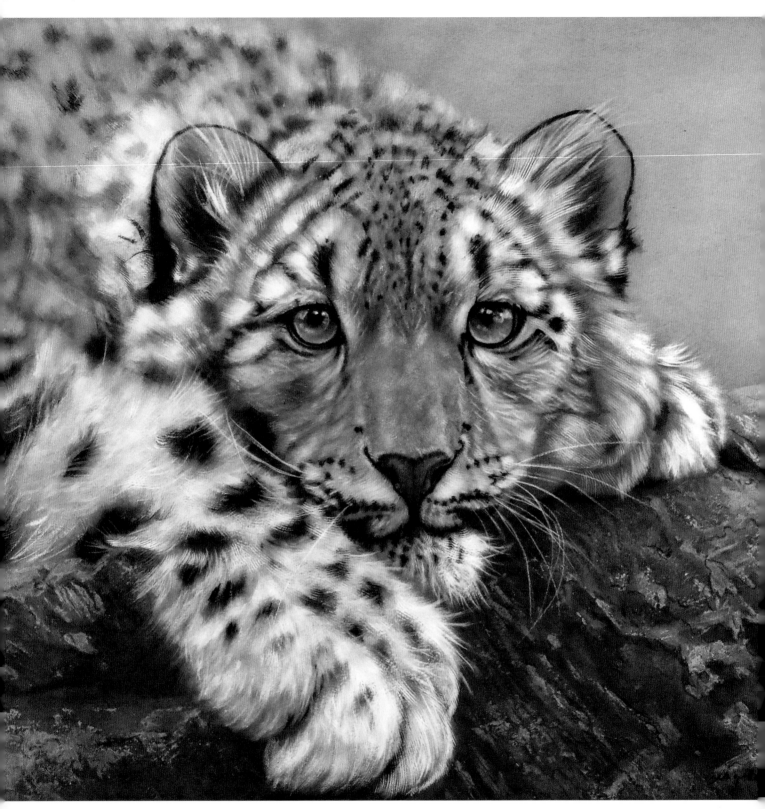

Snow Leopard

73 × 52cm (29 × 21in)

Drawn for a demonstration many years ago; the white fur here was built up in white acrylic and then toned down with the tonal washes. This was done on a Daler-Rowney watercolour board.

Tonal balance

Tone refers to the lightness and darkness of colours, and tonal balance is the skill of ensuring you get the right contrast between the two. For maximum impact, your artworks should have dark shades and light highlights, as in the example here.

The drawing and inking in were done with Inktense pencils, using both Bark and Ink black. To reach the strongest darks I used Ink black, while the midtones were in Bark – this meant that there was sufficient contrast between the two. Were the midtones done in Ink black, I would have had nothing darker to use for the deep shadows.

For the highlights, I went to the opposite end of the tonal scale, using titanium white acrylic to build up the fur texture. By building it up gradually, I could ensure a good balance between the dark, mid and light tones.

In addition to ensuring the tonal balance is eye-catching across the painting as a whole, you can use tone and contrast to direct the eye within a painting. Note how the highlights and shades on the leopard's back (top left-hand corner of the painting) are close to the midtone. The contrast between the spots is not as pronounced as those on the face, where the darks are near black and the highlights are pure white. The high contrast on the face draws the viewer's eye, which helps to bring attention to this important area.

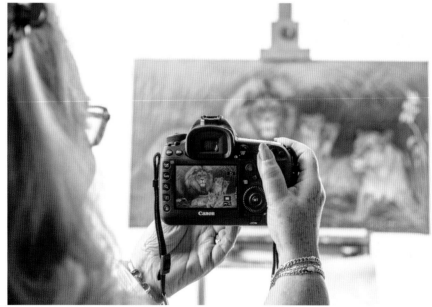

When I think I have finished a painting, I like to take a photograph of it to check that I have a good tonal balance – if I'm happy with it, I sign it off.

Colour temperature

Colour can be used to suggest that some parts of the painting are further away from the viewer than others. Cool, low-contrast areas look further away than warm, high-contrast areas, so by using warm colours, we can draw the viewer's eye.

Warm colours are usually reds and oranges, while cool colours are blues and violets – but colour temperature is also relative: ultramarine blue, for example, is a warmer blue than cerulean blue, because the former is slightly red-tinged, while the latter is slightly yellow-tinged.

In *Mother's Watchful Eye*, the foreground was glazed with pyrrole orange to warm it up and bring it forward, while the trees in the background were glazed with a very thin semi-transparent wash of titanium white to create a very thin haze to push back the background (top left). This helps to bring attention to the lioness watching her cub straying into the shadow.

Both warm and cool colours are used in the lazing lioness' head (middle left) to give the effect of late afternoon sunlight. The contrast between colour temperature here is eye-catching, and highlighted further by the strong tonal contrast between areas in the light and those in shadow. The foreground grasses were similarly made more interesting by using cool turquoise against raw sienna. Strong warm and cool colours interact to draw the eye. Compare this with the distant trees, where both the warm sunlight and cool foliage are relatively soft and muted in hue, which creates the effect of distance.

The lion cub (bottom left) is similar in terms of colour temperature to the surrounding grasses, so I picked him out with tone; using contrast between light and shade to make him 'read'.

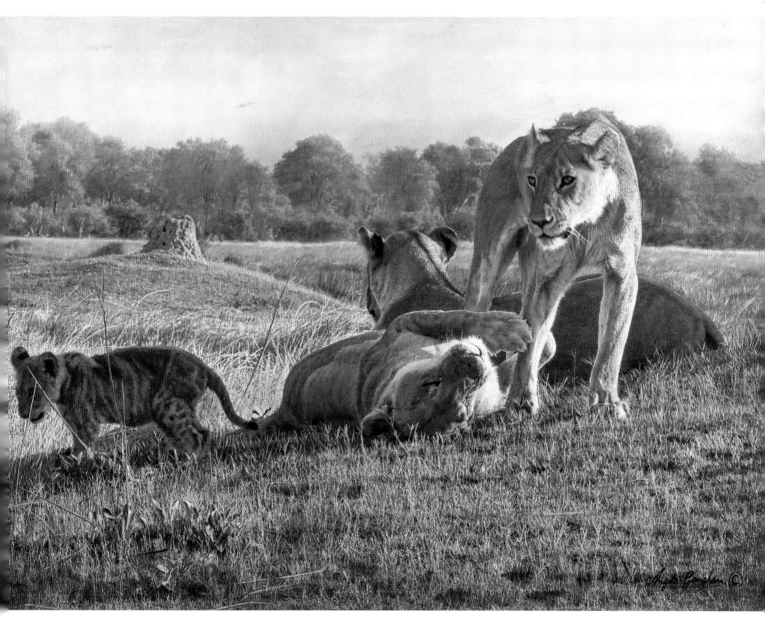

Mother's Watchful Eye

81 × 58cm (32 × 23in)

In this painting I tried to convey the low evening light as the sun was going down on the plains. To achieve this I used pyrrole orange to paint a very warm sun, setting behind the trees, against a very cool sky. The group of lions and the solitary cub are mostly in the shade, apart from the mother and the sleeping lioness in the front, both of which are catching the last rays of sunlight.

Gathering reference

Of course, before you can produce an artwork, you need something in mind to paint! All of my paintings start with research and reference.

Getting to know your subject

When painting wildlife, it is important to find accurate knowledge of its habitat. In particular, if you are showing the animal interacting with its environment, it should be suitable, or the result may appear jarring. The simplest way to ensure accuracy is using a photograph as-is: the bumblebee below was photographed on a cosmos flower, which gave me all the information I needed.

Alternatively, you can use reference. Wildlife books and magazines will give you a lot of information on animals, their prey and habitat. These help to ensure that your paintings' content is as realistic as possible.

Familiarity is a good way to aid research. When painting portraits, whether of people or pets, it is important to get to know their personality. This is why I prefer to take my own photographs and spend some time with the subject. It allows artist and subject to gain each other's trust. When you get back to the studio and you start work on the painting, you remember the bond you shared and it comes out in the painting.

Bumblebee
30 × 23cm (12 × 9in)

Worked purely in Inktense pencil, this bumblebee is pictured on a flower from which this species feeds.

Daisie

61 × 76cm (24 × 30in)

If I had painted the model for this commission painting, Daisie, in a formal background, as often used in portraits, the result would have been too grown-up. I took some inspiration from her name to set the portrait in a garden with a mixture of cottage garden flowers.

This was an opportunity to add more colour, too. To help fit the subject to the background, I added a wooden trolley that she could push through the flowers. The reference for the flowers, which were a mixture of irises, foxgloves, hydrangeas and cosmos, came from my sister Gloria's garden. When I was commissioned to paint her picture, Daisie was only two years old – she is now twenty-two!

Taking and using photographs

A camera can be a powerful and helpful tool to the artist. The strength of a camera is its ability to capture details that we might overlook due to time and/or movement, such as rushing or splashing water. Having details like these in clear focus will prove very useful when you come to refer to them later.

I really enjoy going out on a photography shoot with my husband Mike: we can take hundreds of shots each, and only get three or four really good photographs that are right for me to work on, such as his photograph of the polar bears playing in the water shown on page 106. The lesson is simple – don't wait for the perfect shot: take lots instead, and you will likely find one you love.

Wildlife photography

Shooting animals in their own environment requires a good eye for composition, since this aspect of the photograph is equally important to the subject itself – a fantastic painting of an animal can be spoiled if a vital part of the animal is obscured. Wherever possible, get lots of photographs from different angles and over a period of time, in order to ensure that you have all the information you need.

Good wildlife photographs rely on impact to engage the viewer. A great way to achieve this is through direct eye contact. Shoot with your camera level with the animal's eyes for a more intimate portrait. To ensure accurate focus, align a single autofocus point with one of the animal's eyes. If the animal is not facing you, always focus on the eye nearer the camera – this helps to ensure that the visible part of the face is in focus.

Copyright and permission

Copyright belongs to the creator, whether the piece is a painting, illustration or photograph. It is always best to create your own reference material and to keep records of the creative process just in case you need to prove provenance. If you want to use an image you find online, in a magazine or elsewhere, get permission from the creator unless the image is in public domain and free to use.

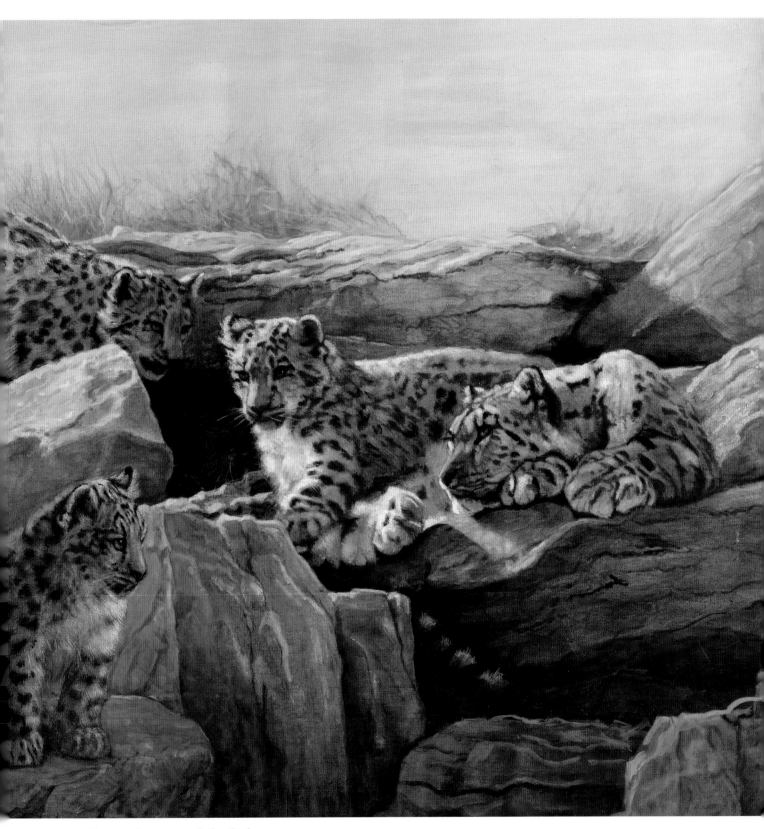

Snow Leopard & Cubs 81 x 61cm (32 x 24in)

A knowledge of how to combine photographs into a coherent scene like this will enable you to create arresting images more easily and enjoyably.

using someone else's photographs

Try to collect as much reference as you can: you cannot have too much. I try to work from my own photographic reference as much as possible. However, you can, of course, work from others' material. I use such pictures in one of two main ways.

The first is to supplement my own images in order to create a new composition. It is not always practical to get reference material of a particular animal's natural habitat, so using someone else's photographs allows me to see the details and colours of a particular place that I have not been able to get to, whether that be the deep cold of the Arctic wastes, or the heat of the African plains. I am very lucky to have friends that offer me use of photographs from their safaris. I use these for background reference to put with photographs of animals I have taken in zoos or wildlife parks.

Secondly, I paint directly from someone else's image. As noted on the previous page, you must always get permission from the photographer to use their images.

Sometimes you are given the perfect photograph, like that shown here, where you can simply and paint what you see. This relies on the photograph being composed well. I really enjoy painting from Tony's reference because the images are so beautifully composed and shot.

If you don't take photographs yourself, try asking friends who do whether you can use their photographs as reference. You might also approach professional photographers to buy photographs from them, or get permission to use them under licence.

THE SOURCE PHOTOGRAPH

Cuddles from Botswana
76 × 122cm (30 × 48in)

The painting opposite was taken from a set of three photographs – one pictured above – given to me by a very good friend, Tony Frazer Price. As it was a close-up, I did not have to worry about the background.

I decided to paint a larger than life-size painting in order to emphasize the intimacy of the love between mother and cub – I jut love the way they are snuggling up to each other. The painting took me longer than I had first thought as I kept getting lost between the spots all the time. With perseverance, however, I got there in the end. All the hard work paid off in the end, as it was the first painting to sell in The Wildlife Art Society International at the annual Nature in Art exhibition.

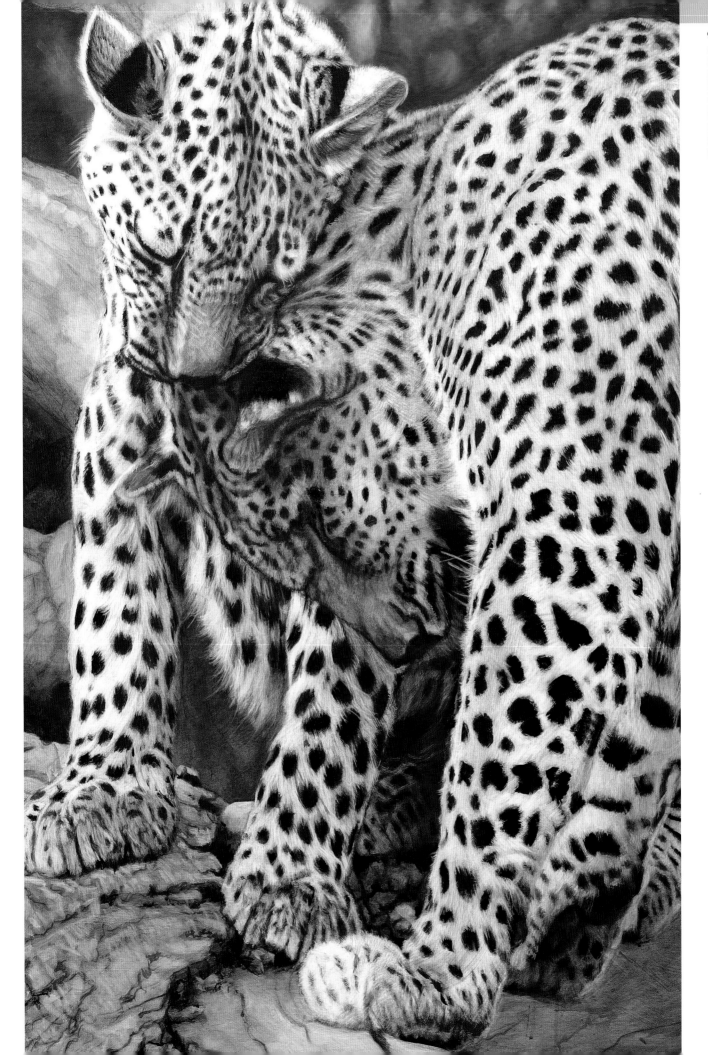

Combining photographs

If you plan to work from photographs, it can sometimes be better to combine elements from several rather than simply copy the entire scene from a single photograph. This forces you to use your own personal creative process to design the painting instead of leaving it up to the camera to do it for you. Designing a painting can be one of the most exciting elements of the painting process, a time of pure creation, where you make up something that never existed before; this is where your expression starts to take form.

You can also work on the fly and adapt your idea as you continue. A good plan is excellent, but shouldn't stifle your creativity. In some cases, adapting will be necessary, as you won't have precisely the image you need.

In this painting, *Simba's Pride*, I used three different photographs, one of Simba photographed in Yorkshire Wildlife Park, another of a lioness and cub photographed in Kenya and another one of grasses. This presented a number of challenges in order to create a natural-looking result.

When you combine photographs, one of the first things to consider is the direction of the light. You have to correct the lighting in the reference photographs to have the light coming from the same direction. Another thing you need to consider when using several different references is the relative size of the various elements you will be combining.

THE SOURCE PHOTOGRAPH

The source photographs have all the elements I want to include, but none of them is perfect as-is. My aim was to combine the best parts of each – the nobility of the adult male lion, Simba, in the first image; the relationship of mother and cub in the second; and the golden light of Kenya from the third. The photograph of Simba was taken by Mike Owens in Yorkshire Wildlife Park. The mother and cub image was very kindly supplied by Pauline and Ian Saggers.

Once I had drawn out the mother and cub, I decided to add Simba (see above) but unfortunately he was facing the wrong way in my source photograph to make a good composition. Since I didn't fancy asking him to move, I had to reverse the photograph so that he faced the other way (see right). In making a change like this, you must be particularly aware of the light – otherwise you risk the shadows on different elements falling in different directions.

The composition looked as I had initially planned, but there was a large 'hole' between the two adult lions, which I found detracted from the composition. To bridge this, I decided to add another two cubs. I found a source for these in some of my old drawings (see left). In order to incorporate them naturally, I had to make sure the cubs were the right size. I did this by measuring the heads and comparing them with the lion cub in the main image. The resulting painting is shown overleaf.

Simba's Pride
84 x 48cm (33 x 19in)

This pride of lions was painted during lockdown for the Covid-19 pandemic in 2020: it took a full ten weeks to complete. I wanted to give Simba a family as I realized how much I missed my family and friends during this lockdown.

The limits of photography

Photographs can capture fleeting light and shadows in an everchanging landscape or a split-second pose of a moving animal, allowing you a glimpse into a moment that is difficult or impossible to capture. They are undoubtedly useful as reference.

Photographs, however, have their limits, particularly when you start out. They should not be relied upon completely. I was lucky in my early days of portrait painting, and could always draw straight from the model. There is no substitute for the experience of working and painting from life, as it is this that will help you develop your artistic eye. I urge you to try working from life where possible to build your skills.

One morning I came down to breakfast and saw my cat, Oscar, sitting on the chair in the window. The light shining on him was so striking that I quickly got my camera to catch the moment so I could paint him in my studio. When I started to look at the resulting photograph, my eye was drawn to the colours in the cushion and the stitching in the quilt that was over the chair. Such details are useful, of course. They can help to create a more interesting and detailed painting.

However, it is precisely because the camera captures everything so cleanly and perfectly, with no distinction between what caught your eye and all the tiny distracting details, that photographs can lead you away from your point of inspiration. In this case, I was interested in catching the lighting and likeness of Oscar that I had glimpsed, and I had to ensure that the painting captured this, first and foremost.

Details like the stitching on the quilt are useful, but only if you have the knowledge and discipline to make sure that they do not overwhelm your initial intent. Know when to pay attention to the detail, but do not lose sight of the piece as a whole.

Using photographs effectively

Our vision is stereoscopic. Lifting your head even slightly will give a different view that makes painting from life necessarily gestural – you can't perfectly replicate your three-dimensional frame of vision on a flat surface. In contrast, photographs are monoscopic, freezing one particular angle. Because of this difference, painting from life and using reference photographs simultaneously can enhance our understanding of the subject by giving us more information with which to work.

Practising working from life is essential to develop your hand–eye co-ordination, your observational skills, and to learn to identify what it is you really want to paint.

Oscar
56 × 71cm (22 × 28in)

This painting captured what I wanted to show – the wonderful soft light on my beloved pet cat. It's also a good demonstration of why it's important to keep an eye on the overall picture as well as the details – it was only after I had finished that I noticed the cushion had been upside-down all along! I decided to keep this detail; it doesn't detract from the painting, and is an authentic reminder of how things really were.

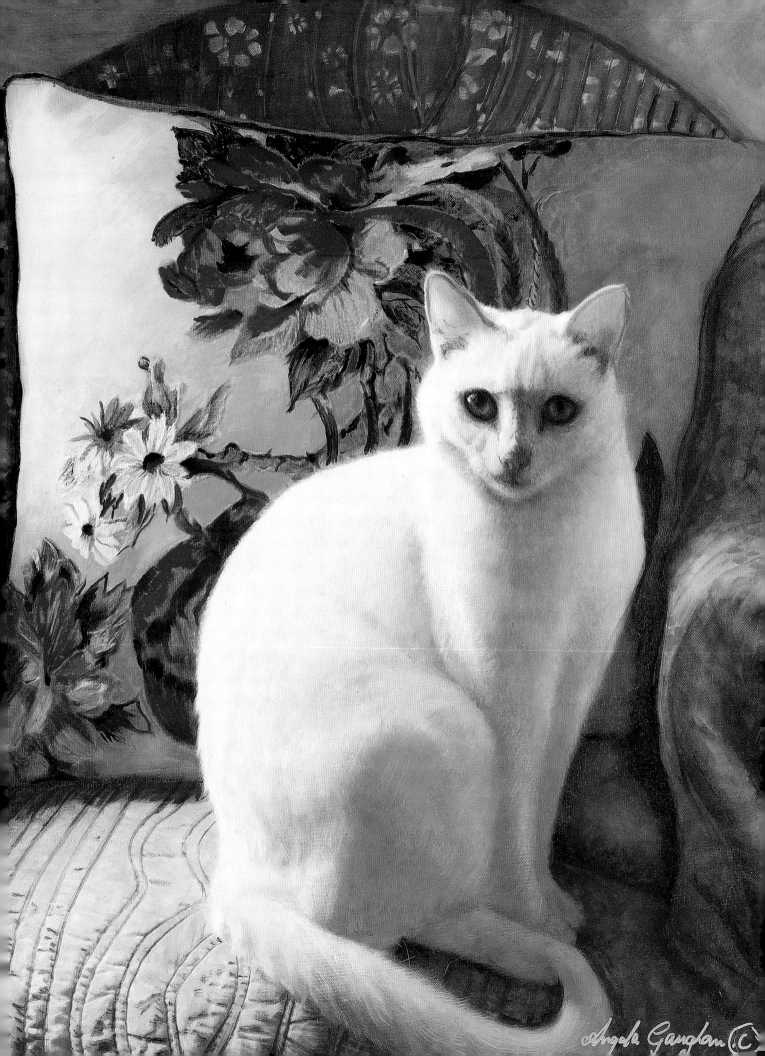

Angela Gaughan ©

Gloria's Clematis

41 x 30cm (16 x 12in)

A dark-toned background helps throw forward a light-coloured subject, ensuring that it remains dominant.

Composing your paintings

Composition is the arrangement of all the structural elements within a painting, such as colour, patterns, shapes, lines, highlights and shadows. An artwork can be beautifully painted, but if the composition is wrong, the result will always feel slightly 'off'.

This chapter looks at some tips for successful compositions, but always remember that you are painting to please yourself.

Starting points

If you plan your painting, you are composing it. You don't need to include all of the starting points below in your paintings, but they are all worth considering. Once you learn to look for these (and similar) guidelines, you can break the rules and get away with it.

Often, breaking the rules will give you surprising and effective results: a pattern, or a texture or something so disjointed that the irregularity becomes regular. Think of Jackson Pollock, Keith Haring or Hieronymous Bosch: all three of these artists have so much going on in their art that almost defies the principles of traditional composition, but their art works.

Focus First of all, your composition needs to have an obvious focal point. What are we supposed to look at? Our eyes naturally gravitate to the horizon, so using a horizon line or perspective is a great way to accomplish this because it establishes context, even in an abstract piece. In an animal or portrait painting, the eyes are another obvious point of focus.

Dominance Much of composition is obvious: the subject is more important than its setting. Even in a landscape, you need something in the foreground and something in the background. Establish what is in front, and what is in the back, even if what you are doing is flat. Another way to look at this is to ask what is dominant or subdominant? You could have a dominant field with a small element that immediately calls attention to itself if it is positioned in the right place.

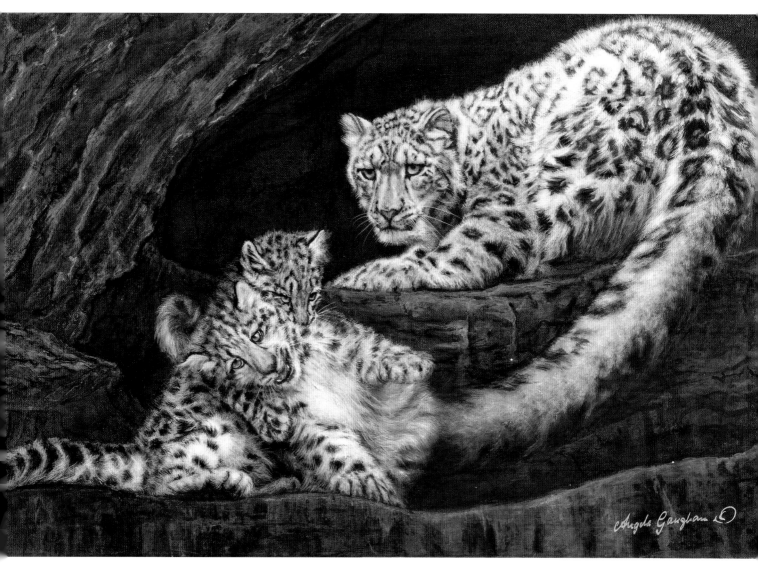

Snow Leopard Family
100 x 86cm (39 x 34in)

Here the playing cubs are the focus, with other elements creating lines leading the viewer from the adult towards the cubs. These lines can be obvious – the tail, for example – or implied: the mother is looking at her cubs, not out of the painting. The background shapes also help to frame the animals, continuing the curve started by the mother's tail (see right).

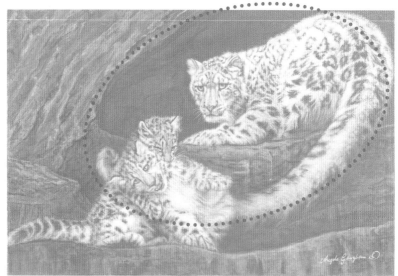

Think horizontal/think vertical Adopting an exteme creates an interesting composition on its own. Something that is obviously very vertical (as in the adult cheetah opposite) or horizontal creates a lot of interest just by being there. Emphasize it to make it more interesting.

Rule of thirds This compositional tool is well-known among most designers, photographers and painters. Divide your field into equal thirds, both horizontally and vertically, so that you wind up with a grid of nine equal rectangles or squares in the same proportion as the whole frame/field; as shown below. You can then align your elements with the grid, especially along the intersections of the grid lines. Remember that there is a difference between asymmetrical balance and almost – but not quite – centred, which looks like a mistake.

The Golden Section This is more advanced and somewhat similar to the rule of thirds but it is more complex: you can arrange elements along the divisional lines and the curves than you can draw between them – sometimes both if you want. Use of the Golden Section is very common in Renaissance art and architecture. You can start with a golden rectangle for the overall frame or apply the proportions to the composition using that framework.

Odd number of elements Even numbers of things get boring in a hurry and can feel static, unless you create variety in the way they are spaced. Odd numbers of things are inherently more dynamic, because they suggest imbalance – and thus movement. Interestingly this is where 'sacred' geometry begins, especially as it pertains to the golden section.

Waterfront
51 × 41cm (20 × 16in)

This aquatone painting uses the rule of thirds to good effect. The waterline runs a third of the way up the painting. A strong dark vertical shadow on the left runs a third of the way in from the left, stopping the eye from drifting along the gentle diagonal and out of the painting.

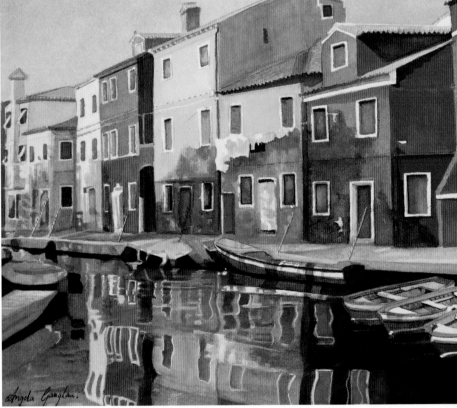

Avoid tangents When edges barely touch, or 'kiss', it creates a weak spot in your composition. Viewers aren't sure what is in front or what is doing the overlapping. I avoid this by keeping my compositions relatively simple. I don't use many overlapping elements.

Split it down the middle Before you dismiss this as boring or static, you can actually arrange things pretty dynamically this way if you do it right. I think of Josef Albers' *Homage to the Square* series, in which concentric squares are arranged on a larger square. They are weighted at the top or bottom but centred on the canvas from side to side. There's a certain elegance to things arranged in neat rows. It creates rhythm.

Watch with Mother

63 x 63cm (25 x 25in)

This picture is an example of a roughly triangular composition that is split down the middle. This naturally makes the adult cheetah the focus, an effect heightened by her direct gaze. Note the inclusion of five animals – an odd number. They are also grouped to create another set of odd numbers: a pair of cubs; a cub and the mother; and a cub on its own. Even within these three groups, there is still further variety in size and pose.

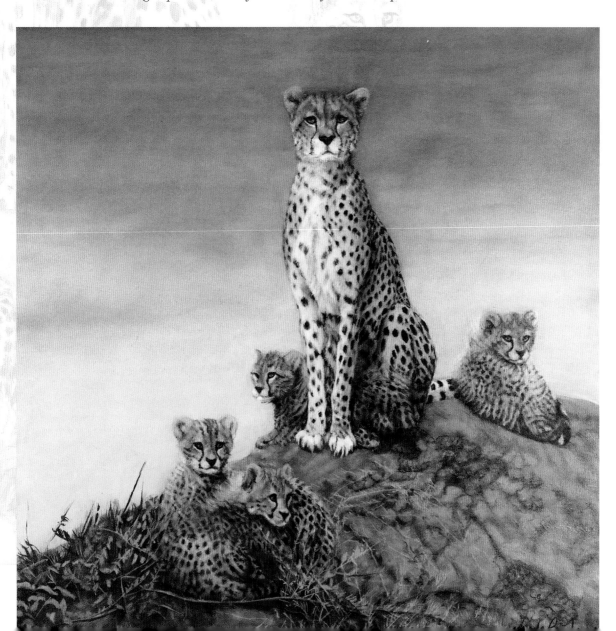

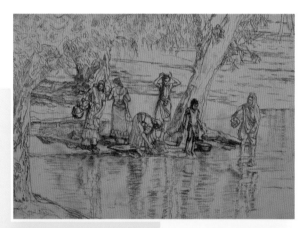

THE SOURCE PHOTOGRAPH

Composition and colour

As explained on page 83, your eye is drawn to tonal contrast, so when I look at a photograph I always start by looking for the darkest darks. This gives me a starting point to work from. However, it is not just tone to which the eye is attracted. Bright colours, particularly reds and yellows, will draw the viewer's gaze, while it will drift over subtle muted pastels (see left, bottom). You can use this to your advantage, by using brighter colours in the areas that you want to be the main focus of your artwork.

In this painting there are quite a lot of dark tones as well as a lot of colour. To prevent the finished painting being overwhelmingly intense, I softened some of the darks on the right, giving the eye somewhere to rest. This also meant that I could keep the darkest darks around the bright colours to draw the viewer's eye to the main focus: the group of women collecting water and washing in the river.

Another important aspect of composition is artistic licence: you do not have to slavishly copy the photograph. In fact, the decisions you make can improve on a photograph – whether this is as subtle as slightly exaggerating a particular colour, or as extreme as removing elements or creating an entirely new background.

In this example, I removed two figures from the group to allow a little more space around the remaining women (see left, top and middle). I also darkened the river colour so that the reflections lead the viewer's eye towards the main focus of the figures, rather than drawing it away from them.

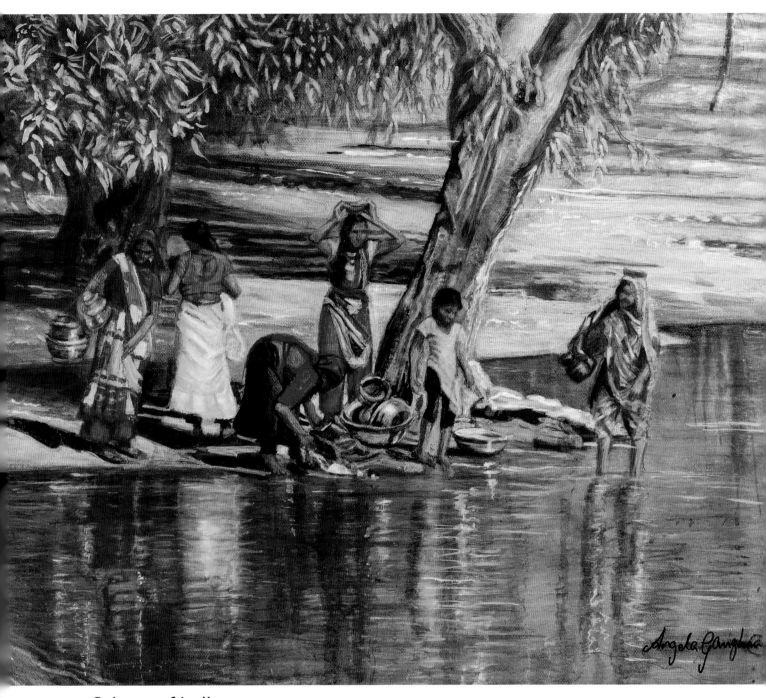

Colours of India 58 × 41cm (23 × 16in)

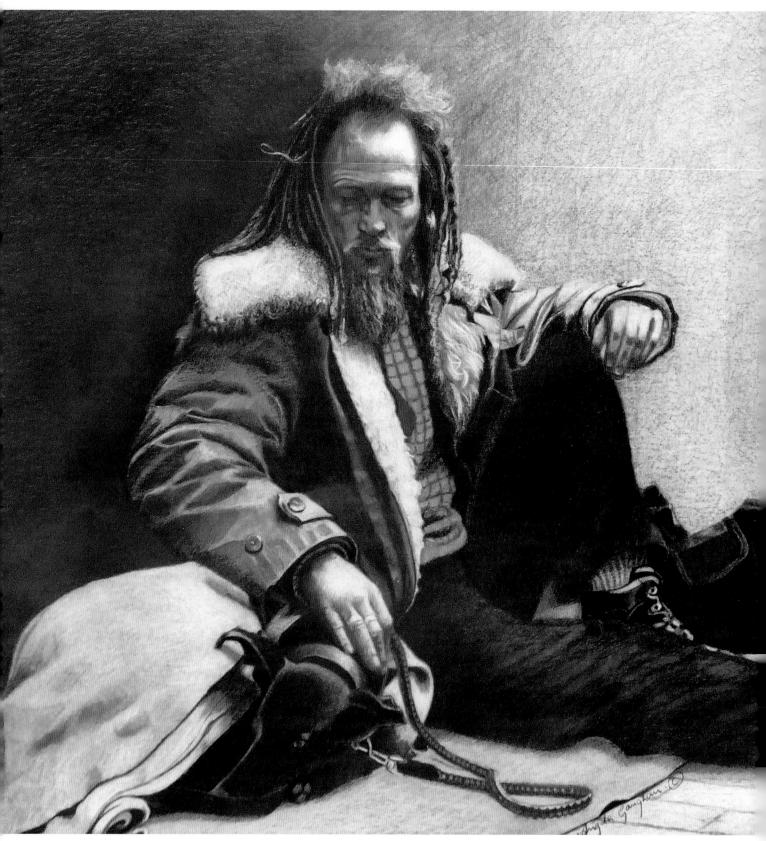

Soulmates 56 × 46cm (22 × 18in)

Animals as a secondary focus

Animals are important to us in many ways, and companionship is a critical one. This painting tells the story of a homeless lad and his strong bond with his dog. The relationship is the most imporant part of the painting, and turns what could be a relatively conventional portrait into a more thoughtful piece that rewards the viewer's continuing attention.

The bright red cap on the floor draws the viewer's eye to the dark colour of the man's leg and up to the light colour of his collar. This brings the viewer's eye to his face, which is the main focus. The viewer's eye then follows the man's own gaze, down his arm to the dog, telling the story of his love for and strong bond with his dog. That his eyes don't meet the viewer's conveys the contemplative mood and atmosphere, and his expression and affectionate gaze makes it clear that his dog is a partner and companion, not a simple item, like the hat.

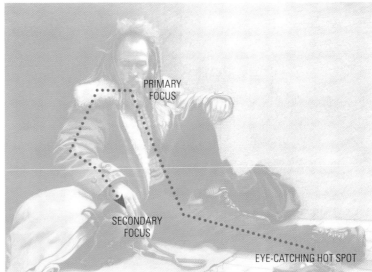

The path of the viewer's eye is illustrated above, and the diagram also highlights another compositional technique that I have used here: the background is split into light and dark sections – roughly one third and two thirds – to help frame the figure. Note that the dog's blanket is light, contrasting with the dark background here. This helps with contrast and impact.

Background choices

Even though the background may not be dominant (see page 98), it is still important to consider it when composing your work.

The sort of background I will put into a painting usually depends on the subject. If it is a commissioned pet portrait, I will go with what the client requires. This can mean a complex background, but plain backgrounds are also popular: they ensure that nothing distracts from these beloved pets. The dog portraits on page 117 and 123 are good examples of how plain backgrounds let the subject speak for itself.

Sometimes I paint the subject first and then decide what to paint in the background. Whether person, still life or animal, the subject is the most important part of the painting and so should have the most detail.

Finally, there are some compositions in which the existing background is critical, as in the example here. In these cases, you may need simply to crop the photograph correctly and begin work.

THE SOURCE PHOTOGRAPH

Background tips

Hot spots These are distracting areas of high contrast that can take the viewer's eye away from the subject. Avoid them in your backgrounds.

Carry a camera You never know when you will see something you can use in a painting, and this applies as much to backgrounds as subjects.

Consider the atmosphere Muted colours work well for a relaxed feel, while a dark background can add drama.

Stay alert When you are outside, look around you to find backgrounds. Sometimes I will set out specifically to look for promising trees, logs or long grasses that I can use in paintings.

Keep it simple Clear sky or foliage provides a simple, uncluttered backdrop.

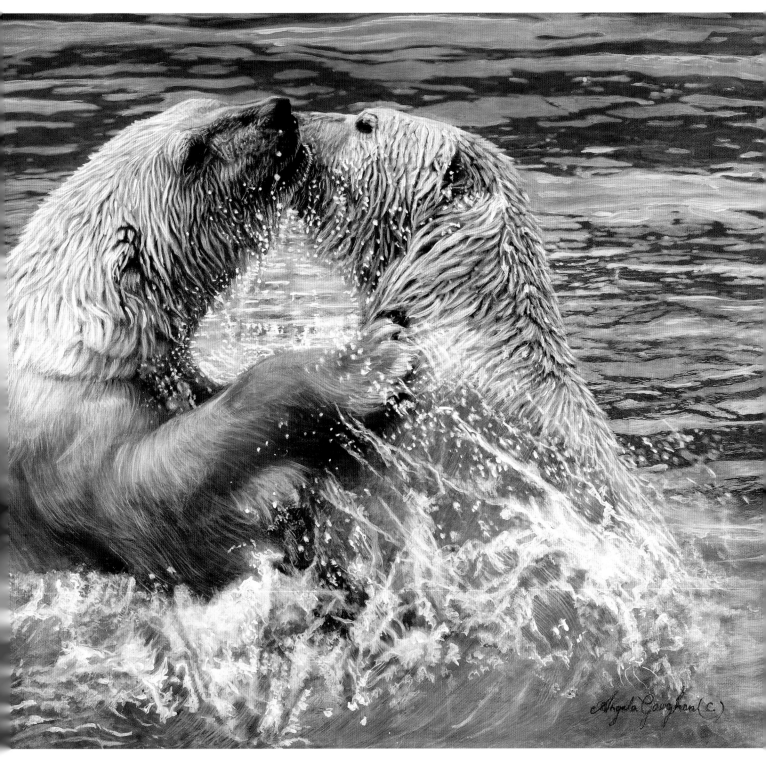

The Kiss

84 × 58cm (33 × 23in)

The polar bears that are the subject of this painting were photographed in Yorkshire Wildlife Park, Doncaster, UK. The water in which they are playing has a crucial role in the composition, so it could not be left out or altered too greatly. Beyond leaving out the foreground grass, which I felt distracted from the bears, the only change was to the colours, to give a fresh, clean feeling to the piece.

Re-wilding animals: changing the background

As wonderful as many wildlife parks and zoos are, it is likely you will want to change the background of photographs taken of animals there; both to de-clutter and improve the composition, and to place the animals back in their natural habitat. In these cases, I use the photograph purely to study the anatomy and likeness of the animal, and rely on research to pick a suitable background.

Research is important for convincing backgrounds. It is worth repeating the lesson: the background should be appropriate – a wintry setting might suit a snow leopard or polar bear, but wouldn't be the right place to set a lion. Such an extreme example is obvious, but it also applies to other subjects. If you are adding it later, you need to make sure the background works in harmony with the subject.

Today we are very lucky, particularly when researching settings for animals. In addition to traditional sources of information, such as libraries, there are lots of nature programmes on television, and huge amounts of information available on free websites.

Sometimes your research will throw up some choices. With the polar bears you know it's going to be snow or ice – or sometimes rock or grass depending on how far they travel. In cases such as these, you may wish to choose a particular setting in order to help the composition, create a more iconic scene, or simply to try something a bit different.

I usually keep things simple as in the painting *Sleeping Beauty* here. After I had studied the polar bear, I decided to depict him lying in soft snow, with the setting sun in the far north leaving a soft warm pink glow. In addition to accurately depicting the environment of the bear, this allowed me to experiment with the warm and cool colours, and I enjoyed playing with my favourite colours pyrrole orange and phthalo turquoise.

When painting the light in the painting I was careful to paint the cold reflected light bouncing off the snow onto his fur. This is important – if you change the background, you must make sure that you integrate the animal with the setting in this way; otherwise it will simply look 'stuck-on'.

THE SOURCE PHOTOGRAPH

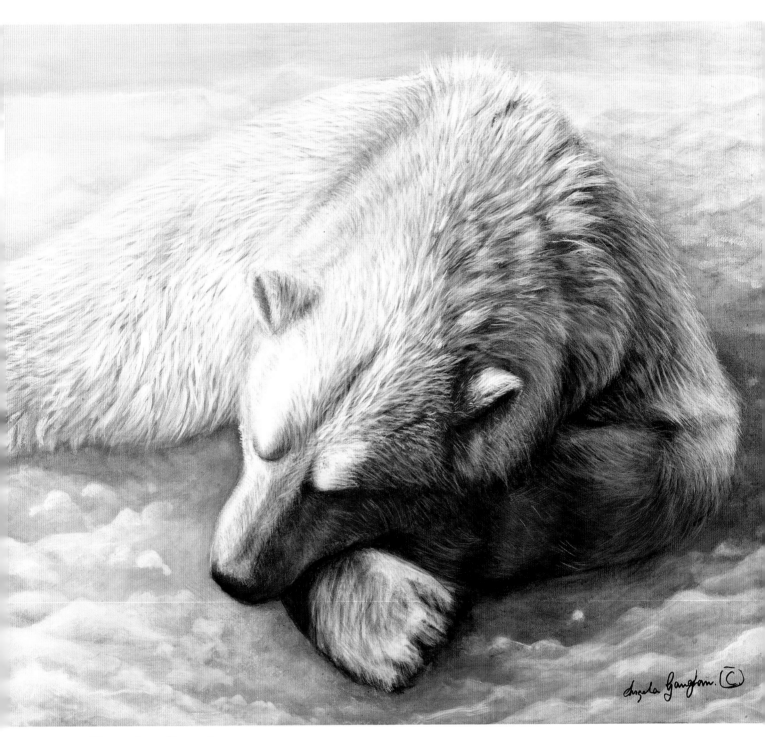

Sleeping Beauty

84 × 58cm (33 × 23in)

In this painting I wanted to portray the size and beauty of the polar bear. I drew the bear from a photograph that my husband took on a photoshoot at Yorkshire Wildlife Park, Doncaster.

As you can see, I have changed the background to suggest he is in his natural environment; most of which I painted from my imagination. I wanted to give the impression of the sun setting on the left, just out of sight but leaving a soft pink glow.

THE SOURCE PHOTOGRAPH

Simplification

Sometimes all your plans fall into place – or you are just very lucky and capture a photograph that needs little, if any, alteration. In these cases, don't over-think things, and work with what you have.

Of course, it helps to have lots of potential shots to sift through: give luck a helping hand by taking plenty of shots, particularly of dynamic subjects such as moving animals – or in this case, a musician.

Ivan is an extremely good guitar player we met on a cruise ship on which we were teaching art: he was one of the entertainers. As I watched him perform, I knew I had to paint him, so after approaching him to ask permission, we photographed him performing. Mike took over two hundred shots of him while I made notes of his skin tones and the colouring of his hair and clothes.

After sifting through all the photographs, I selected this one as I liked the format. The composition is almost a pyramid, drawing the viewer's eye through the painting from the hand on the left to his hand on the right against the light guitar; and then travelling up his arm in shadow to his face in the light which I wanted to be the main focus.

The only real change I made was to simplify the background, removing the clutter to leave the focus on the subject. Here I was careful to use the original to guide me. Note the blue light falling on Ivan in the original (see the middle picture) – I used a matching hue for the background: another colour would have looked wrong.

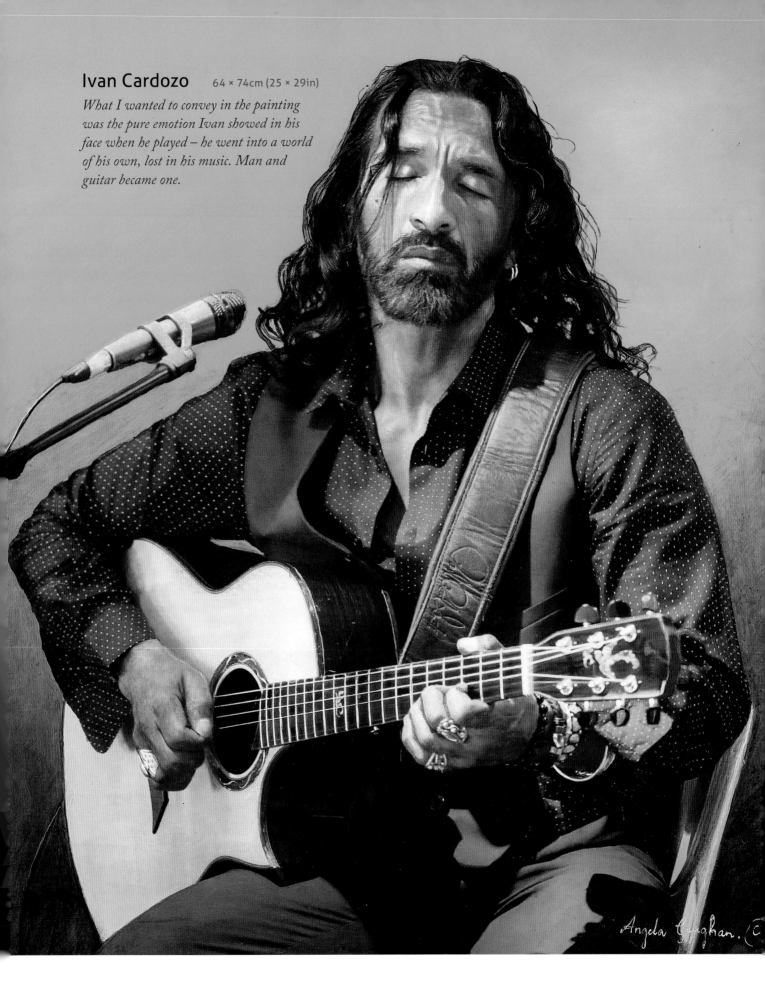

Ivan Cardozo 64 × 74cm (25 × 29in)

What I wanted to convey in the painting was the pure emotion Ivan showed in his face when he played – he went into a world of his own, lost in his music. Man and guitar became one.

Angela Gaughan. ©

Masterwork techniques

A ttention to detail and patience are the key facets of painting lifelike artwork. There is no substitute for careful observation, nor for the number of layers required to build up depth and richness. As you practise both, you will find your work improves and improves.

Try to think of every painting as a journey. Sometimes it may be a short journey, sometimes a very long journey. With this in mind, it's perfectly fine to have a detour or a rest – painting is, after all, an enjoyable pastime, not a duty to be endured.

The techniques and examinations of finished paintings that follow are intended to help you both to develop your skills in more specific directions, and to tackle particularly complex or important elements of painting wildlife. I hope my experience helps you with your own painting journey.

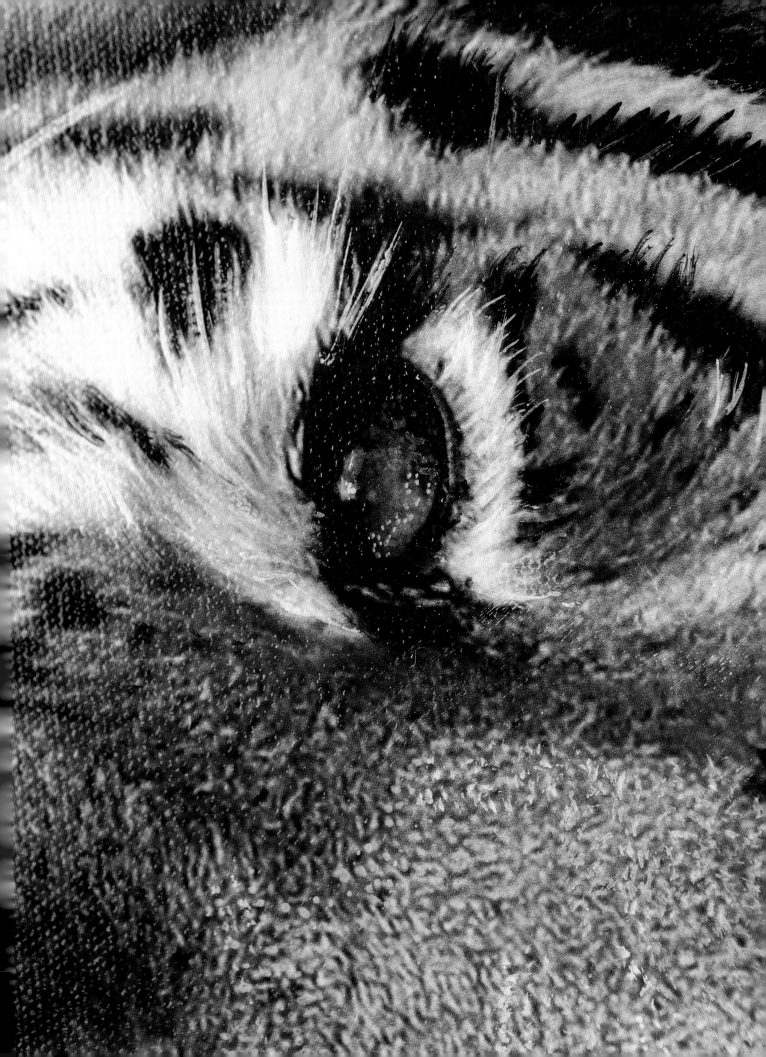

Time and space

'How long did it take you to paint that?' It's a question I'm commonly asked, but a difficult one to answer. When I start a painting, I don't think about how long it is going to take before it is finished; nor do I necessarily work away at a painting from beginning to end. For instance, some paintings, like the elephants bathing shown here, took about four weeks from drawing to completion, but then it sat in the studio for about three weeks while I considered the composition – and eventually changed it. Ought I to say, then, that it took four weeks, or seven?

Time and space for thinking and considering are important parts of the painting process, and an understanding of this is critical to making your work the best it can be. Barrelling forwards and pushing through in your urgency to finish something is not always the best approach.

Giving yourself space simply to observe objectively is critical. Sometimes you become so engrossed that you lose the ability to accurately gauge the piece as a whole. In this example, something nagged at me about the master copy (see below), so I set the piece down. Returning to it three weeks later, with a fresh eye, helped me to see the problem – my gaze drifted out of the lower right-hand corner of the painting. With this identified, I added in a battered tree trunk at the bottom, pointing towards the elephants. This helped to lead the eye to the left-hand elephant – the focal point – and framed the painting.

So, you see, I just enjoy the journey. I still have paintings sitting in my studio that are not finished, but I know intuitively that the ideas will start to flow at some future point and they will come to fruition. Give yourself time and space to bring your paintings to the best result you can.

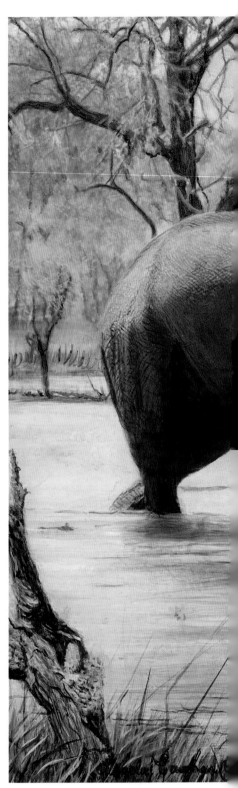

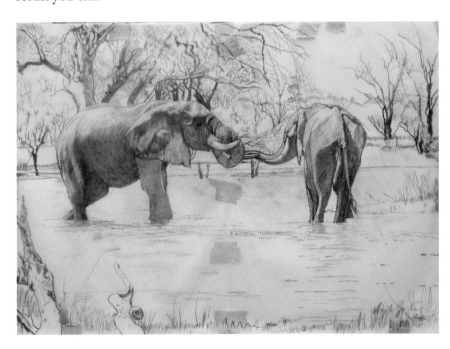

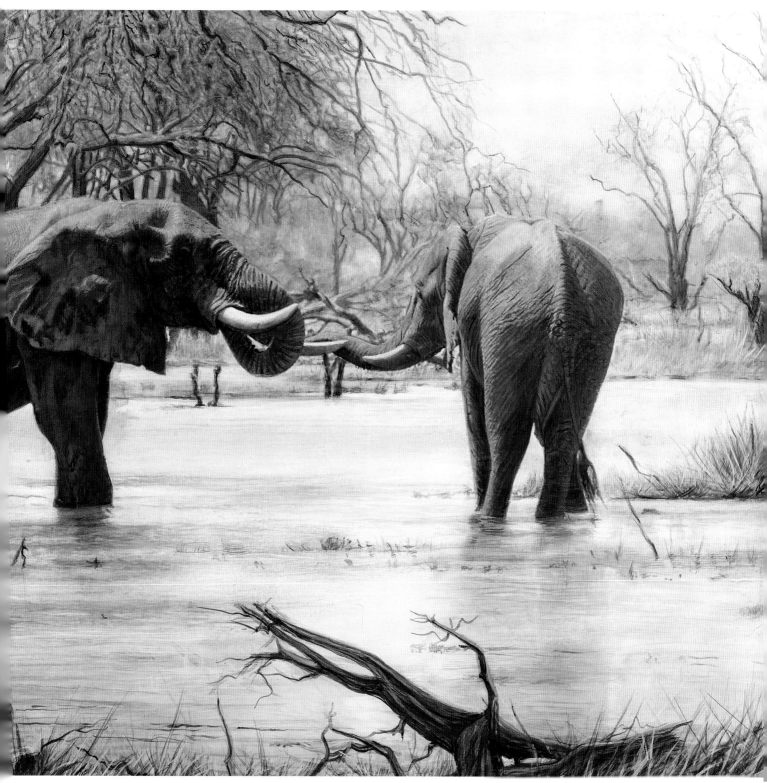

Early Morning Bathe 84 × 58cm (33 × 23in)

Black fur

Black fur often includes ginger hairs and blue aspects in certain lighting. What we're looking for here is not a dead, flat black, but a rich, colourful depth of tone. To do this, we glaze lots of different colours that neutralize each other and gradually build up to create the impression of deep black fur. Unlike other colours of fur, black rarely includes pure white hairs, so the highlights are always glazed back with at least one layer of colour.

1 As you might expect, we start from an Ink black Inktense base. You can start from another colour, but it will take longer to develop the reqired tone.

2 Using a pointed oval wash brush, lay a wash of burnt sienna over the whole area. Keep this flat and smooth, then allow to dry.

3 Once dry, use the small spiky comber to pick out highlights with strokes of titanium white. Use these to indicate the form of the subject.

4 Once dry, glaze ultramarine blue over the area using a large spiky comber. Aim to leave a few small gaps; with subsequent layers, these will help to add variety and interest to the fur. Once dry, use a small spiky comber to pick out the highlights again, reinstating them. Pick out slightly fewer highlights this time.

5 Repeat the process with glazes of alizarin crimson, ultramarine blue and burnt sienna, alternating each glaze with more white marks, gradually reducing the number and size. Leaving out more and more highlights ensures the area gradually becomes more subtle with further layers.

6 Continue building up the tone and value in this way, alternating between adding gradually fewer and fewer highlights in white, and glazing the various colours. As you come to the final stages, look to see the overall hue of the fur in the light – are the highlights red-tinged and warm, or blue-tinged and cool? This can help you to decide on the final glaze to use.

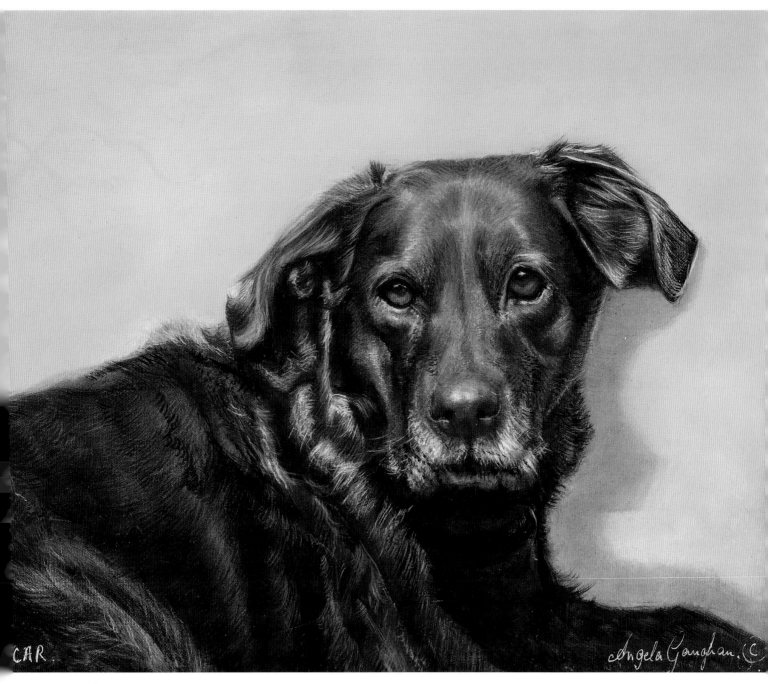

Oscar

51 x 41cm (20 x 16in)

Building up a sufficiently dark tone takes time and many layers, but using the approach shown opposite will create luminousity and subtlety within the black fur that you cannot achieve any other way.

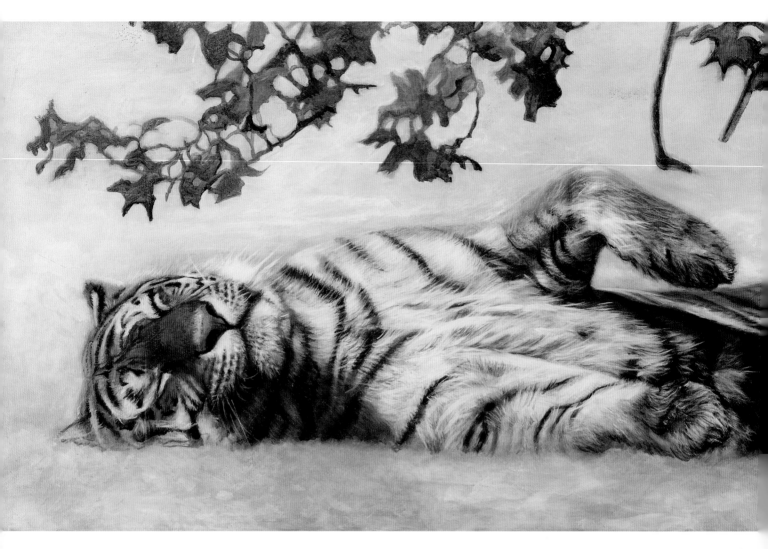

white fur

White fur can be intimidating. It is difficult to judge tones against white, so the result can appear dirty and grey (if the shading is too strong) or without form (if not enough shading is used). Close observation is the key. You will quickly find that 'white' fur is rarely pure white; being affected by the light on the animal, its surroundings and, frequently, dirt. It therefore helps if you think of white fur as a very light tint of a particular colour. Once you identify the local colour, you can use glazes of appropriate hues to subtly bring it out.

In addition, the apparent colour of white fur is affected by secondary light. In fact, you could say there is no such colour as white, as it will reflect whatever colours surround it. To paint white fur, we thus need to use glazes that reflect the animal's environment. In *Contentment*, here, for example, I have applied blue glazes in selected areas to suggest light reflecting from the snow. In *Sleeping Beauty* on pages 108–109, I glazed very thin phthalo turquoise over the tiger's white fur in areas.

The way I paint white fur is to paint titanium white brushstrokes in the direction that the fur is lying. I then glaze very thin washes over the top. For shadows, I use ultramarine blue, adding burnt sienna on top to darken it further where needed. These two colours produce a vibrant, rich neutral tone when they are used in concert.

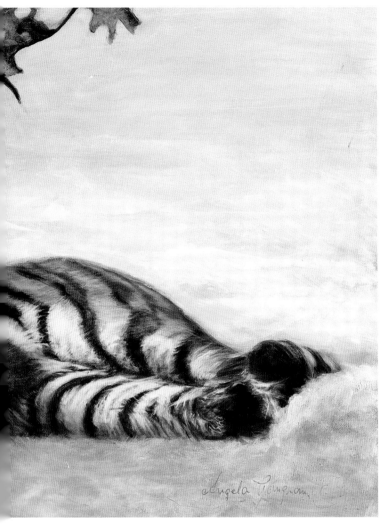

Contentment 91 x 38cm (36 x 15in)

THE SOURCE PHOTOGRAPH

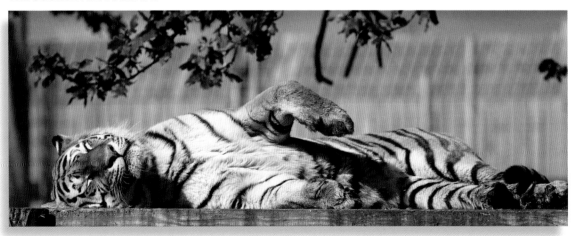

Eyes

When I paint a portrait, I like the eyes to be the main focus. As you look into the eyes, observe any other colours that are there. The eyes of the snow leopard are a cold blue, for example. This technique uses tinted opaque white to create brightness.

1 Starting from an Ink black Inktense base, use a small spiky comber to paint the eye with a very dilute wash of lemon yellow. Wash over the whole eye, including the pupil.

2 Allow to dry, then touch in small areas of phthalo turquoise with the small spiky comber.

3 Once dry, add tiny touches of burnt sienna. Start underneath the lid. The motion is like a very controlled stippling.

4 Mix a little phthalo turquoise with titanium white on a palette.

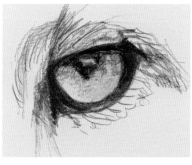

5 Use the size 00 rigger to spot in this opaque tinted turquoise. The opacity stops it from mixing with the layers below, so you end up with a bright, clean effect.

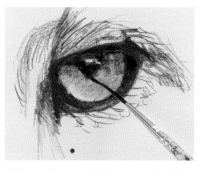

6 Once dry, rewet the eye and add more vibrancy to the turquoise area using phthalo turquoise.

7 Reinstate the highlight with titanium white. As an optional finishing touch, you can overlay the eye with glazing medium. This adds a glossy finish.

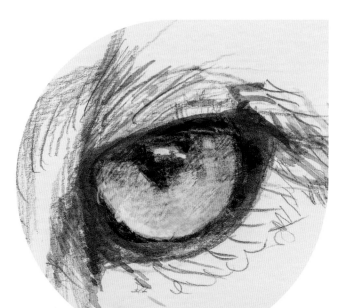

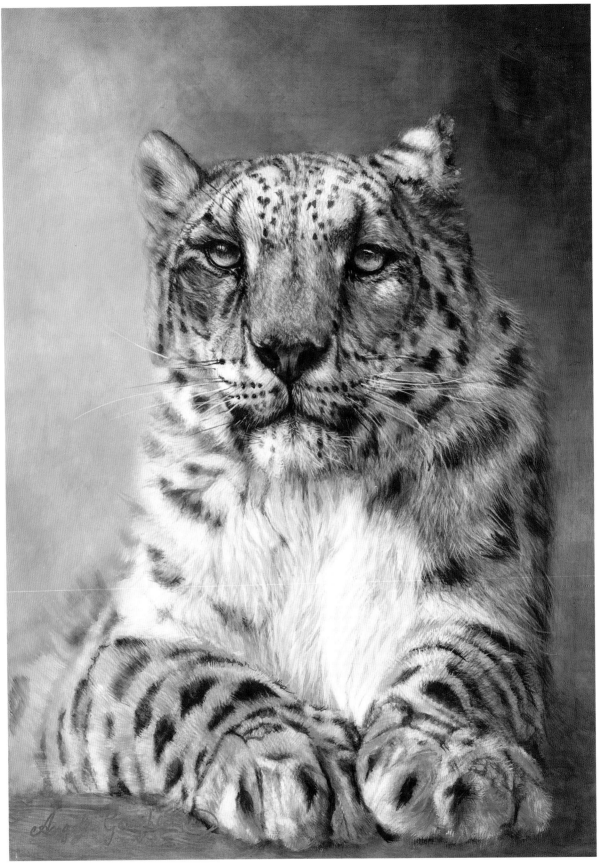

Snow Leopard 48 x 69cm (16 x 20in)

Dog's eyes

Being the focal point, all eyes deserve especially close study. Mikey's eyes, for example, are a very pale amber colour. With a very knowing look he looks straight at you, as though trying to work you out.

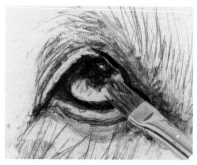

1 Using the small spiky comber, paint lemon yellow over the underdrawing and allow to dry.

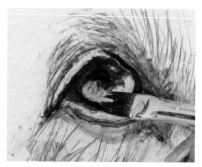

2 Tint the left-hand side of the eye with a glaze of burnt sienna, leaving the lemon yellow showing on the right.

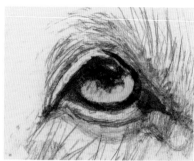

3 Once dry, use the small spiky comber to touch in raw sienna over the whole eye, to enrich the colours. Allow to dry.

4 Swap to the 00 rigger to paint burnt sienna over the left-hand side of the eye, deepening the shadow.

5 Add a hint of titanium white as a highlight.

6 Once dry, glaze under the eyelid with ultramarine blue.

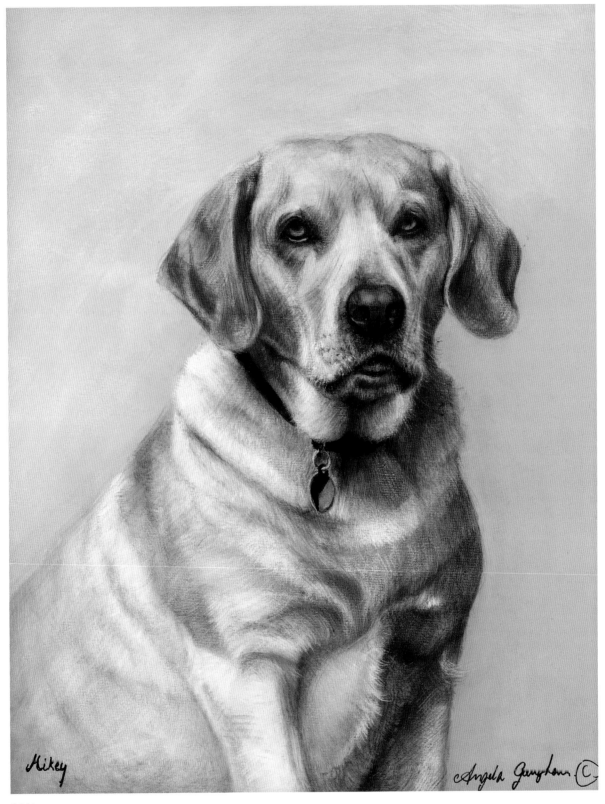

Mikey

41 x 51cm (16 x 20in)

Mikey belongs to Mr John Walton. This was part of a commission to paint his two beloved dogs.

Feathering

With a lot of my portraits I like a soft diffused background. A soft background helps to ensure that the main subject remains the focus – literally, as the techniques here break up lines and reduce contrast, which results in a blurring effect.

This technique works effectively only at the end of a painting, because you need a number of layers on the canvas to ensure it is smooth. As well as for backgrounds, it is ideal for other soft, diffused elements, allowing you to add light and colour wherever you want.

You can continue using the same mop brush, simply wiping it off on dry kitchen paper, until it becomes dirty. At this point, you risk depositing paint back on the surface, so you need to stop, and wash and dry your brush thoroughly before continuing.

Tip

This approach is not just for animals. For portrait work, I often use the colours of the sitter's eyes when choosing colours for feathering. In my portrait of Mike (see page 69), his eyes are a mixture of grey, blue and green, so I used these colours in the background.

1 Over your prepared background, lay in the number 8 medium (see page 46) with a pointed oval wash brush.

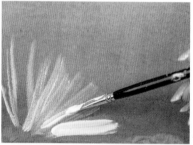

2 Use a small brush and titanium white to add some shape – in this case, I'm suggesting distant foliage. We use titanium white because it's opaque, with good coverage.

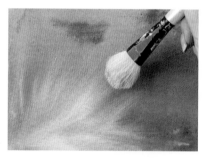

3 Use a clean, dry mop brush to wave over the marks, barely touching the surface. This will break up the brushmarks and lift away a little paint from the surface. Use sweeping, whispering motions in the direction of the original brushmarks.

4 Add strokes of your second colour (this can be any colour) with the small brush, then repeat step 3, using the mop brush to soften the edges. Clean and dry the mop brush regularly – it's critical that the bristles remain dry throughout.

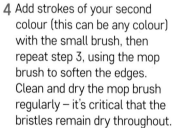

5 Continue to build up the effect. You can continue working while the surface remains wet – the medium ensures it remains workable for a long time.

6 You can add details in the same way, simply by introducing more small areas of white, adding colour, then feathering with the mop.

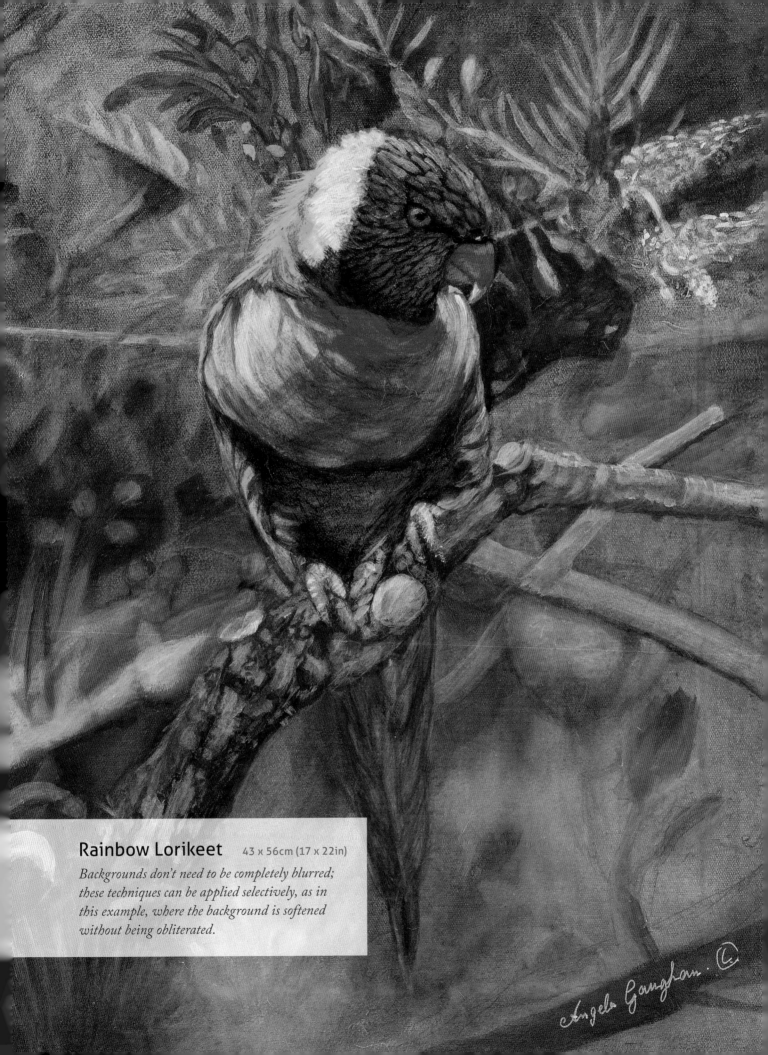

Rainbow Lorikeet 43 x 56cm (17 x 22in)

Backgrounds don't need to be completely blurred; these techniques can be applied selectively, as in this example, where the background is softened without being obliterated.

Angela Gaughan.

underpaintings in different colours

I always used to produce my underpaintings in shades of grey with the darkest tones in black, but many artists will use brown. As long as you can get a good tonal scale you can use any colour as long as you can achieve good darks.

Brown underpaintings, or *brunaille,* add warmth to a painting – as in the example here. Despite the subject having black fur, I used a brown underpainting here because I wanted an overall warm, inviting scene. A *grisaille* (that is, a black-based underpainting) will result in cooler darks – perfect for snow-based scenes.

At root, as long as the colour you choose can produce the dark tones you need, the precise colour you use is really a matter of choice. Experiment yourself and see which you prefer.

You Lookin' At Me? 104 × 79cm (41 × 31in)

The detail of the brunaille underpainting is above. Although the gorilla's fur is black, it has warm aspects.

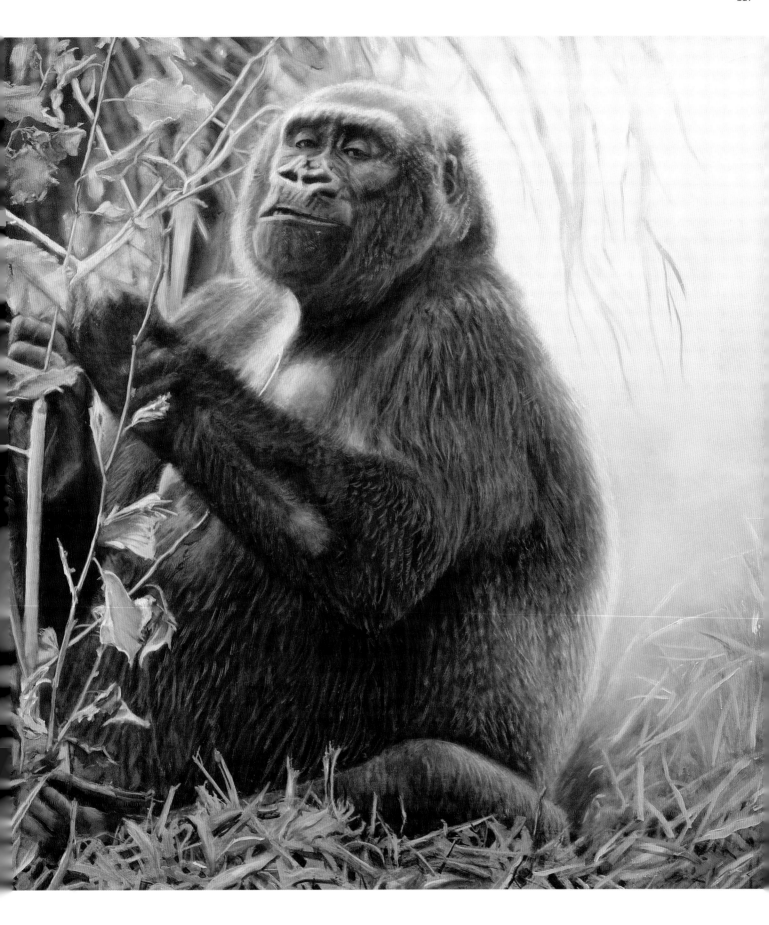

Water and reflections

Water is rarely completely motionless. Even when calm, the surface will show subtle ripples and undulations. Expressing this slight movement is fundamental to capturing the essence of water on a static canvas.

Ripples in water generate irregular abstract patterns that are jagged, zigzagged, circular or curved. Identify and isolate these shapes and patterns before turning your focus to colours. Remember that perspective affects the size of the patterns: shapes nearer to you are bigger than distant shapes, which get progressively smaller. Water patterns are irregular; resist the temptation to repeat them, and break the rhythm.

I make it easy for myself by doing a tonal underpainting of all the abstract patterns in the water before I wash in my colour glaze. Note that I also include the broken reflection in the underpainting. As with other elements of the painting, time invested in the underpainting will be rewarded in the result.

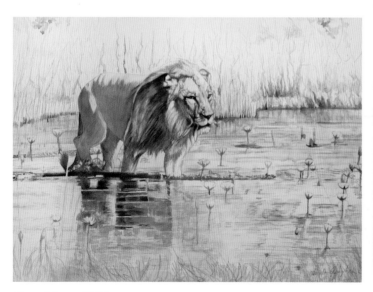

Cooling Off 81 × 61cm (32 × 24in)

The tonal underpainting above shows that the main shapes of the reflection are established early on. In a painting like this, where the reflection plays such an important role, you need to give it as much attention as the subject itself.

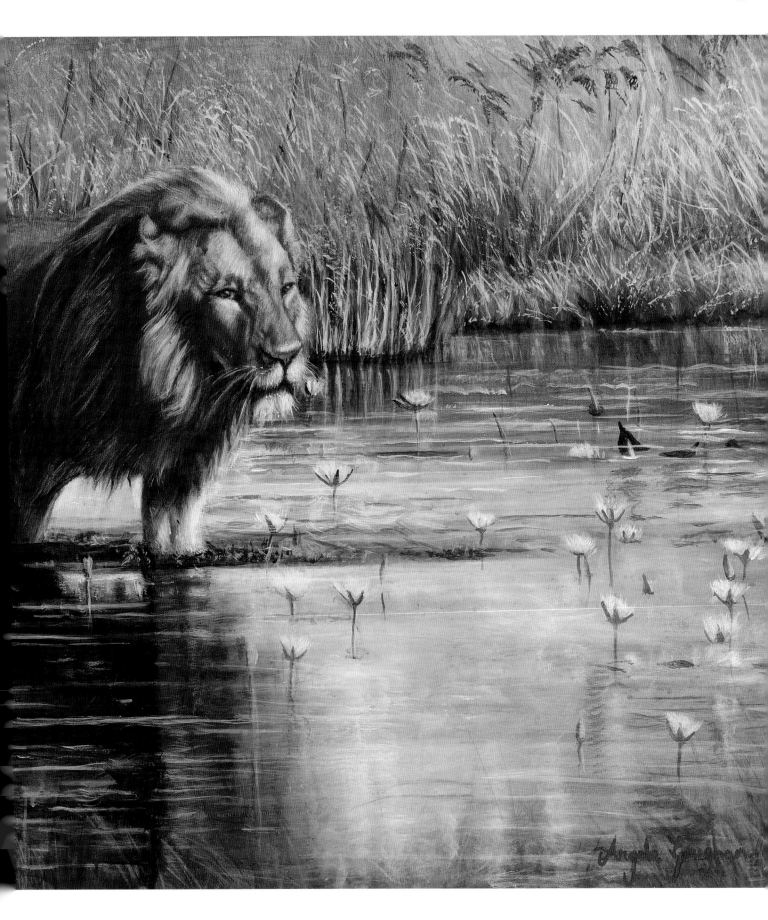

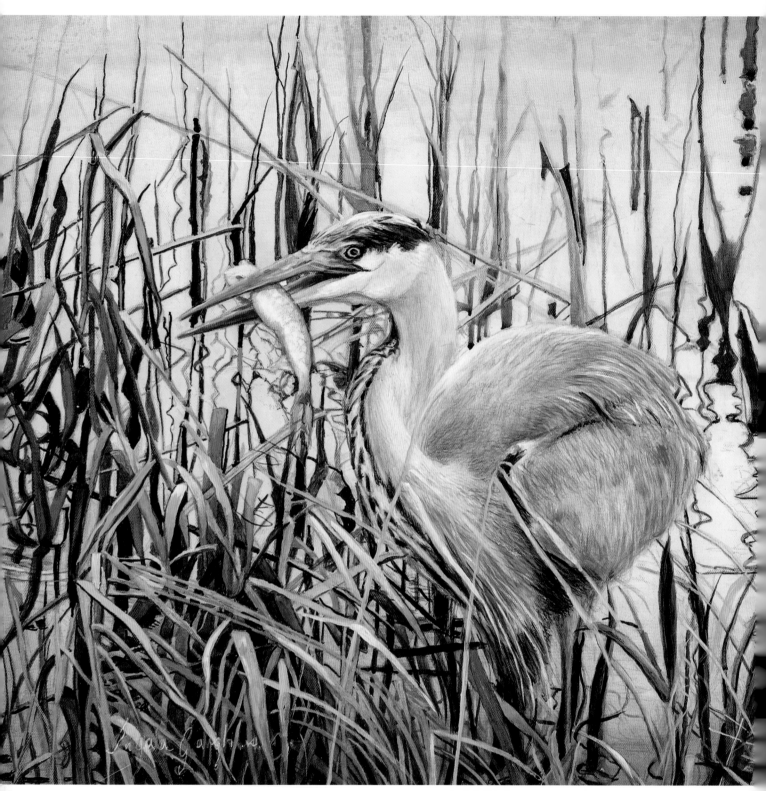

Early Morning Heron

61 × 46cm (24 × 18in)

This heron was photographed fishing for his breakfast in the reeds. I did not have to worry about the background or even what he eats, as all the information was in the photograph, kindly provided by Pauline Saggers.

Still water

Observing the water's surface to analyze abstract shapes and patterns is key to success, but is quite hard to do, because the eye tends to follow the changing movement. This is why I like to take photographs as they offer a static view and are ideal to study your subject.

Try turning your photograph upside-down to fool your brain and use your eyes to examine the shapes, colours and values. This will help you to paint what you see instead of what you think you see.

Sometimes a calm body of water, such as a pond, shows that one area is reflective (showing sky or trees) while another is transparent so that the pond life is visible (pebbles, fish and plants).

Capturing movement

Just as with water, it is hard to analyze and capture animals in motion. Capturing moving animals is thus best achieved by accurately copying a photograph of an animal or animals in motion. Once more, this demonstrates how important it is to have good reference.

Creating the illusion of motion requires specific skills. One way to do this is by selectively blurring parts of the animal with feathering (see page 124).

Another way to imply movement is by repeating elements in the painting to echo the direction of the movement, as in the painting shown here. Notice how patterns in the water and splashes are all moving in one direction.

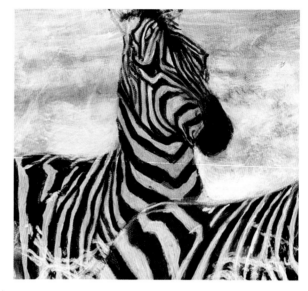

The off-balance pose of this zebra helps to create the impression of dynamism. While the posture is not one I might select for an individual portrait, as part of a group it contrasts with the poses of the rest of the herd, further heightening the sense of movement.

The legs churning up the water suggest both power and movement. Note that the legs are partially hidden by the water – again creating a sense of blurring and naturalistic movement.

The water was built up using layers of phthalo turquoise and titanium white, allowing some of the underlying burnt sienna to show through. Accurately building it up took several washes and careful study of the water patterns. To help with the blurring of the water areas, I glazed my number 8 medium (see page 46) over the whole canvas to slow down the drying time. This allowed me to blur and soften areas of the water and to give me time to observe the direction and placement of the splashes.

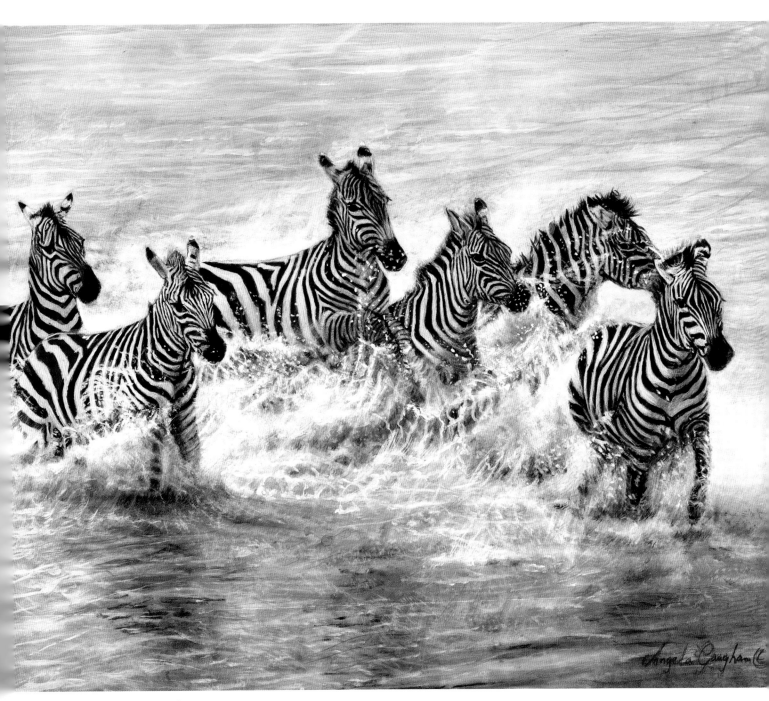

The Crossing

81 × 61cm (32 × 24in)

*The photographic reference for this painting was kindly given to me by Sue Shelton-Smith,
and I worked on this painting all through Patchings Art Festival 2019.*

*I thoroughly enjoyed the challenge. I drew the zebras directly onto the canvas and spent
some time erasing and re-drawing until the shapes and angles were correct. When I was
happy with the drawing, I inked in the darks and left it to dry. I then sealed the pencil and
Inktense drawing with a wash of very thin burnt sienna acrylic over the whole canvas.*

Foliage

Today's artists are very lucky: cheap, reliable technology and cameras means we have a vast amount of excellent reference on foliage, making this potentially complex subject easy to break down and study in detail. The same principles as always apply in terms of drawing and painting: accuracy and a good eye will enable you to identify shape, form and tone when drawing your master copy.

The critical thing to bear in mind when painting foliage is that your main subject has to be the focal point in a painting. Whatever the colour of your background foliage, it must not compete with your main subject, but rather help to frame it. This means that you must pay particular care to balancing the tones against the animal subject.

In this example, I ensured the spruce trees (see right, top) behind the wolf were quite dark to provide contrast with the pale fur of the wolf. I also kept the green here quite blue-toned, which helped to push it back into the background. Note that the main branches point towards the wolf, subtly leading the eye towards the subject.

The wolf's fur has an attractive, warm tinge of burnt sienna which helps to draw the eye. In order to ensure the light-toned wolf remained dominant, and to prevent it from blending into the background, I darkened the tones of the similarly rust-coloured leaves (see right, middle) in the background. This created contrast, with the eye-catching lighter tints reserved for the foreground.

My tip when looking at a lot of green foliage (see right, bottom) is to see how many colours you can pick out. There will likely be yellows, browns, reds, greys and blues. Don't be afraid of colour: it is all around us, if we just take the time to use our eyes and look.

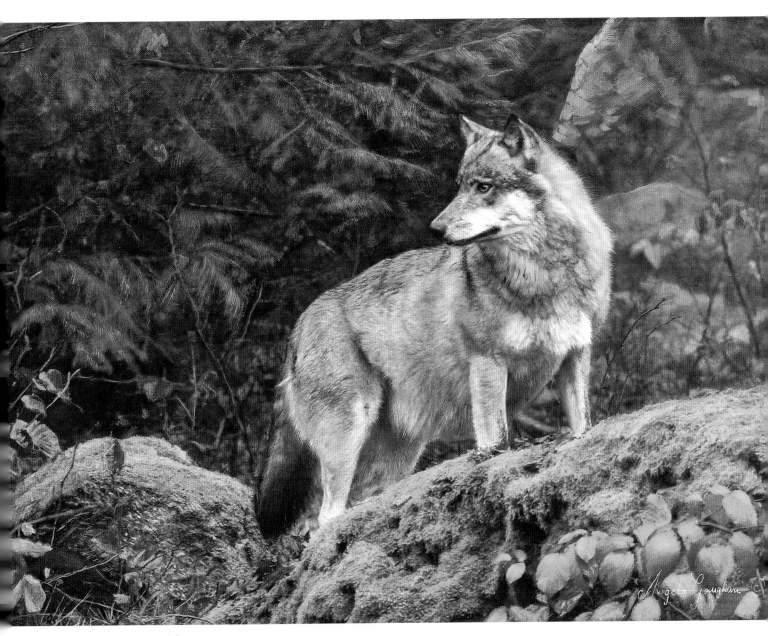

Lone Wolf

81 × 51cm (32 × 20in)

Depicting a beautiful lone wolf, I wanted to use a little more colour in this painting to set off the subtle hues of the wolf's fur. I opted to place the subject against the varied and colourful foliage of its verdant forest in its native Bavaria. Rusty red leaves help to add colour in the middle and foreground, but in the background I kept the green spruce trees a soft grey tone of green.

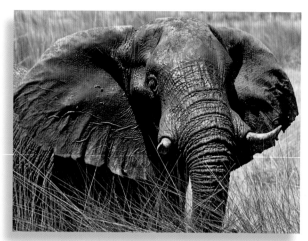

THE SOURCE PHOTOGRAPH

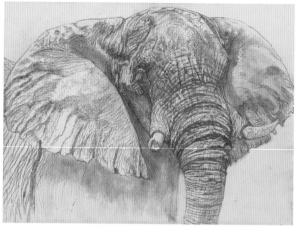

Master drawing in graphite. Note the weight of the pencil tone, even at this stage.

Elephant skin

Elephant skin is very highly textured: wrinkled and thick. Because repeated glazing gradually softens lines and reduces contrast, it is really important to build up the texture of the skin correctly. You need a lot of strong contrast between the lightest light and the darkest dark, so that every lump and bump is recorded.

When I did the master drawing for the painting opposite, I started with a very detailed graphite drawing as usual, then I started to pick out the darkest darks with Ink black. Using these deep tones to guide me, I started to pick out every wrinkle (as shown middle right). It took a few days to complete the finished tonal underpainting.

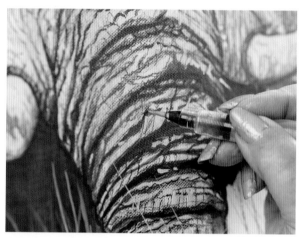

When applying the Inktense, it is important to keep the marks crisp and sharp, and to build up a sufficiently deep tone.

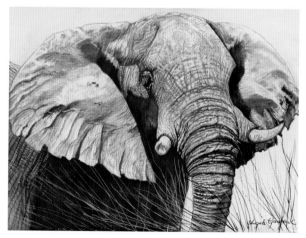

The completed tonal underpainting.

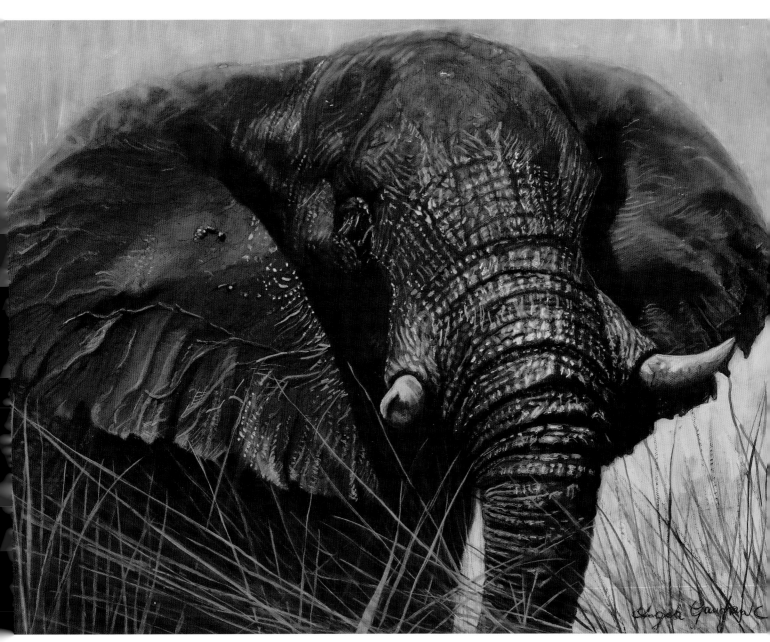

Majestic Beauty

56 × 41cm (22 × 17in)

As you can see from the details on the opposite page, most of the work was done in the tonal stage. I started with the first washes of thin burnt sienna on the elephant. Lemon yellow in the background gave me a base to paint into. I next picked out the highlights in the skin with opaque titanium white. Once this was dry, I started to re-glaze the burnt sienna and ultramarine violet very thinly over the titanium white. Once dry, ultramarine blue was glazed over the shadow areas to cool them down and pyrrole orange washed very thinly over the warm areas. I carried on searching out the colours in the skin and tinting them in, and finished by putting in the background grasses.

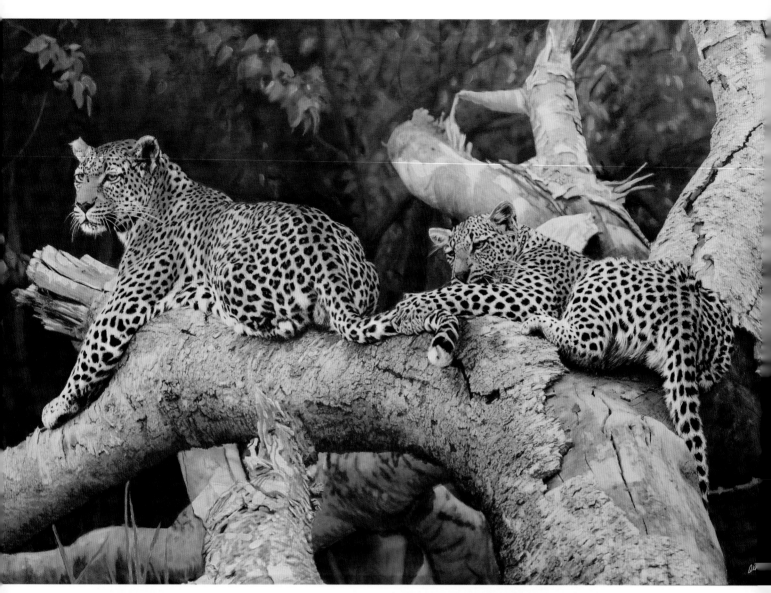

Holding on to Mama 122 × 76cm (48 × 30in)

As with Cuddles from Botswana *on page 91,
I wanted to draw attention to the leopard cub holding
on to his mother's tail. Having chosen this as the focal
point, the surrounding bark needed to share a similar
amount of detail in order to look naturalistic. The
remainder of the background was left diffused and
softer, in order not to distract from the focal area.*

Tree bark

There is no great secret in how to achieve realism in your depictions of tree bark. As usual, the detail must be accurately rendered in your master drawing and the dark shade correctly established on the tonal underpainting with Inktense pencil.

For *Holding on to Mama*, pictured here, I used a black tonal underpainting, produced with Ink black Inktense pencil. Close observation is very important, which highlights the importance of good reference for both subject and background. It's no good staring at a blurry photograph; so make sure that it's not just the animal that you capture clearly when gathering reference.

The large size of the canvas made things easier (I have cataracts in both eyes, and the larger the piece, the easier I find it to place detail accurately) but it also meant that it took me a long time to draw this on to the canvas and ink it in. Patience, and a genuine desire to slow down and enjoy the work, is also important for complex textures like the bark of this tree.

Once happy with the tonal work, I laid a very thin wash of raw sienna over the whole tree. Once dry, I put in burnt sienna where you can see the warm patches of colour. All the patterns in the bark were then painted with opaque titanium white to give the bark texture.

The darks around white pieces of bark (such as those seen in the middle left detail) are the original Inktense black lines done in the tonal stage, sealed in with the initial raw sienna wash. You can see how important that first drawing is. From there, it was a matter of tinting in colours as and where I needed them.

When working on bark, remember to keep your washes or glazes very thin, like watercolour, so you never lose your underdrawing. After many layers of glazing, you might have to darken some of the darks to correct the tonals.

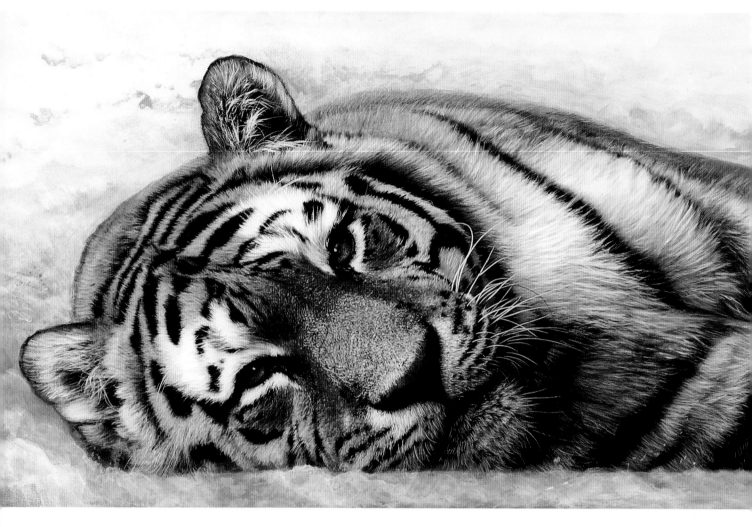

Light and shadow

Vladimir is a beautiful Amur tiger which we photographed in Yorkshire Wildlife Park, UK. Mike and I spent the whole day taking photographs of him. I picked one of him sleeping after a snack as the basis of the painting on pages 8–9.

A couple of years later I decided to paint him when he was awake and looking directly at the camera. I wanted to give Vladimir the space and freedom he deserved, so the viewer can concentrate and enjoy his beauty.

I also decided to paint him virtually at life size so you can feel his strength and presence, allowing me to put in all the detail of this beautiful animal.

In both paintings, I changed the background to have him lying in snow, as he would have in his native Russia. This involved removing the wooden platform the tiger was lying on and changing the diffused background of the fence into snow.

When changing the background, it is critical that all the shadows are in the right place – this avoids the impression that the subject has been cut out and placed on a different background. When doing so, look at both the light and colour and take the new setting into account. You'll notice here that the reflected light on the white fur is painted with blue, to help suggest the snow.

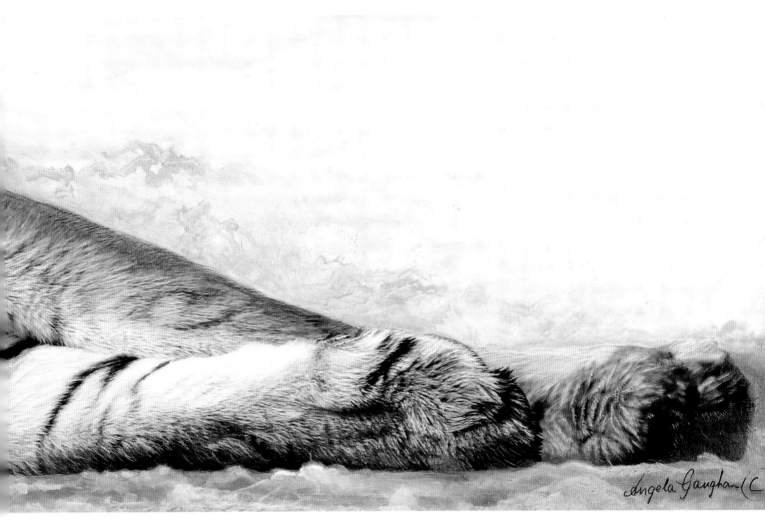

Vladimir

119 × 36cm (47 × 14in)

THE SOURCE PHOTOGRAPH

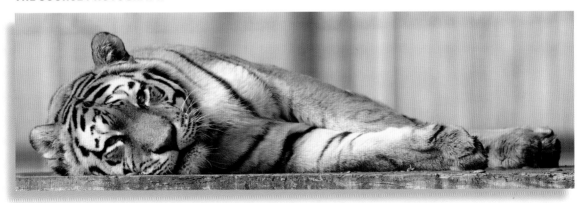

Tip

When painting wildlife, you rarely have the choice of working from life – they will not pose or sit for you, so using the camera is a must.

'Paint what you want to paint'

Afterword

I wrote this book to give you an insight into my approach to painting – and, perhaps more importantly, to inspire you to create your own little world.

A life of painting has given me a passion for recording everything around me – the wonderful colours and textures of the natural world. Whatever the subject, whatever the medium; when faced with a new painting challenge, I still find myself just as excited as I did all those years ago when I first began to paint.

I wish you the best in your journey into a world of beauty and colour. At its best, painting uplifts your spirits; helps you to forget the problems of the world; and opens your eyes to see the beauty of this wonderful planet on which we live.

Index